The Corning Museum of Glass

A Guide to the Collections

D0890552

The Corning Museum of Glass
Corning, New York

Editor: Richard W. Price

Designer: Jacolyn S. Saunders

Photographer: Nicholas L. Williams,
 with the following exceptions:

Pages 4, 7, 25, 63, 79, 121, 141, and 159:
 © Peter Mauss/Esto.
Page 103: Frank J. Borkowski, Corning, New York.
Page 180: Photo by Gabriel Urbánek.
Page 182: Photo by Fred Scruton, courtesy
 of Tony Shafrazi Gallery.

ISBN 0-87290-152-1
Library of Congress Control Number 2001 131713

Prepress work coordinated by
 Graphic Solutions, Painted Post, New York
Printed by Upstate Litho, Rochester, New York

Contents

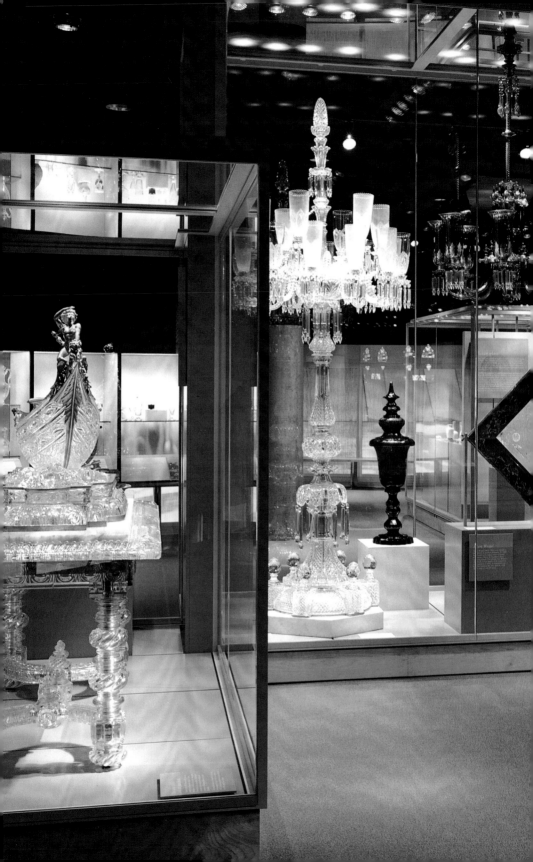

Introduction

To mark its 50th anniversary in 2001, The Corning Museum of Glass undertook a $60 million program of renovation and expansion. As part of that project, the Art and History Galleries were redesigned and reinstalled. The Museum's Rakow Research Library, which had adjoined the galleries, was relocated to a new facility, opening up a considerable amount of space for additional exhibits. The new gallery layout is larger, more open, and better lighted than ever before.

The galleries relate the story of glassmaking in chronological order. The story begins with the Ancient and Islamic Galleries, which are divided into three areas. "The Origins of Glassmaking" traces developments from the second millennium B.C. to the early Roman period. "Glass of the Romans" starts with the discovery of glassblowing and ends in the seventh century A.D. "Glass in the Islamic World" concentrates on Islamic glassmaking between the seventh and 14th centuries, but it also contains objects made in India and Iran in the 18th and 19th centuries.

The European collection is housed in two galleries. The first focuses on early glass, including Venetian Renaissance vessels, glass in the Venetian style, and pieces from the Northern Baroque period. Eighteenth- and 19th-century objects are displayed in the second gallery. Among its highlights is an impressive arrangement of large-scale furniture and chandeliers made for world's fairs. Key pieces from the Strauss Collection of drinking glasses have been integrated into the layout of these galleries to provide a more comprehensive portrait of styles and techniques.

Three galleries are devoted to American glass. "Glass in America" includes the collection's most important pieces of 18th- and 19th-century American glass, as well as a hand-operated pressing machine and a model of a cylinder glass factory. "Crystal City" features outstanding objects made by glass cutting and engraving businesses in Corning, which was a center for the production of cut glass for nearly a century—from 1868 to 1962. This gallery also contains cutting apparatus, film footage of an early 20th-century cutting shop, and information about the selling of glass at the turn of the 20th century. The Carder Gallery, located next to The Studio of The Corning Museum of Glass, offers a detailed look at one of Corning's most distinguished glassmakers, Frederick Carder. During the 82 years in which he worked with glass, this gifted English designer managed Steuben Glass Works, exper-

The Corning Museum of Glass houses the world's greatest glass collection. It contains objects representing every country and historical period in which glassmaking has been practiced.

imented with many ancient glassmaking techniques, and produced an astonishing variety of pieces.

"Modern Glass" and "Glass after 1960" present 600 objects covering a range of artistic movements in glass. The displays begin in the 1880s with European and American Art Nouveau, followed by Art Deco from the 1920s and 1930s, Italian and Swedish design at midcentury, and studio glass from the early 1960s to the early 1990s. This collection features a diverse array of vessels, sculpture, lighting, furniture, windows, and panels made by more than 100 artists and designers.

An international overview of 20th-century glass sculpture, from the minute to the monumental, is housed in the Sculpture Gallery. This innovative environment presents many of the objects unencumbered by glass cases, and encourages visitors to walk around these pieces so as to view them from different perspectives.

Two smaller exhibits are devoted to Asian glass and paperweights of the world. The Asian glass display ranges from ancient Chinese beads to Japanese luxury glass of the 19th century to colorful wedding baskets made in Indonesia in the early to mid-20th century. The collection of paperweights includes examples from all of the major French producers (Baccarat, Clichy, Pantin, and Saint Louis), as well as works from factories and artists in England, Bohemia, Belgium, Russia, and the United States.

The new Study Gallery is named in honor of two of the Museum's most generous benefactors: Jerome Strauss, whose collection of nearly 2,500 drinking vessels came to us by gift and by bequest in the 1970s, and his wife Lucille, who bequeathed funds that were used to construct the gallery. The Study Gallery contains objects from all parts of the Museum's collection.

This guide presents a brief introduction to each of the historical periods represented in the Corning collection, followed by descriptions and illustrations of key objects on display. If you have yet to see our galleries, please consider this volume to be your personal invitation to pay us a visit soon. If you have already toured the exhibits, we hope that the guide will serve as both a memento of your visit and an inspiration to explore the world of glass in greater depth.

David Whitehouse,
Executive Director
The Corning Museum of Glass

The Origins of Glassmaking

This gallery illustrates the ingenuity of the earliest glassmakers, who used a variety of techniques to shape and decorate glass objects. These objects include vessels, jewelry, inlays, and sculpture.

Glass was first made before 2000 B.C. in Mesopotamia (now Iraq and northern Syria). Glassmakers fashioned beads and other small objects by casting molten glass in molds or shaping it with tools. Then, in the 16th century B.C., Western Asian craftsmen made vessels by trailing or gathering molten glass around a core. About 1450 B.C., this technique was introduced in Egypt, where glassworkers used it to create vessels, figurines, jewelry, and furniture inlays.

Shortly before 1200 B.C., civilizations declined in Egypt, Western Asia, and the eastern Mediterranean. For the next three centuries, few luxury goods were made, and few glass items dating from this period have been found. Then, around 900 B.C., glassmaking was revived in Mesopotamia and Phoenicia.

By the fifth century B.C., glassmakers in the Achaemenid Empire were producing cast, cut, and polished vessels of excellent quality and superb finishing. Some of these objects imitated gold and silver vessels. In Egypt, craftsmen used casting techniques to make tiny sculptures and glass inlays.

Glassworkers in the Hellenistic world made multicolored mosaic glass, spectacular vessels for eating and drinking, and objects decorated with gold foil fused between two layers of glass. At one time, scholars attributed the finest Hellenistic glass to workshops in Alexandria. Now, however, they believe that workshops must have existed elsewhere because Hellenistic glass has been found in a wide area around the Mediterranean and Black Seas.

For centuries, glassworking techniques were so labor-intensive that only wealthy customers could afford to buy glass objects. In the second century B.C., the first step toward making cheaper glass took place in the Syro-Palestinian region, where glassmakers began to make cups and bowls by slumping disk-shaped blanks over molds.

The Roman conquest of the eastern Mediterranean had little impact on glassworkers, who continued to produce cast and polished vessels. However, between about 30 B.C. and A.D. 70, some of the finest Roman luxury glass—including ribbon-mosaic and gold-band objects—was made.

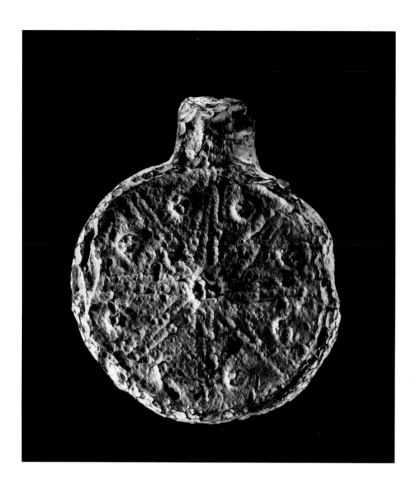

Pendant decorated with a star

Northern Iraq, Nuzi, 1450–1350 B.C. H. 5.5 cm (63.1.26).

This pendant decorated with a star is an early example of glass formed by casting. The glass was melted and pressed into an open one-piece mold, as is indicated by mold marks, folds on the underside of the glass, and overflow at the outer edge of the pendant. Disk-shaped pendants, either plain or decorated with a star, have been found at a number of sites, mainly in northern Mesopotamia. Similar pendants have been excavated throughout the eastern Mediterranean, from the Syro-Palestinian coast to Mycenaean Greece. The star motif is often associated with the goddess Ishtar in Western Asiatic mythology. Ishtar, who is better known as Astarte, was the Assyrian and Babylonian goddess of love and war. The presence of a threadhole in the pendants suggests that they were probably worn about the neck as amulets.

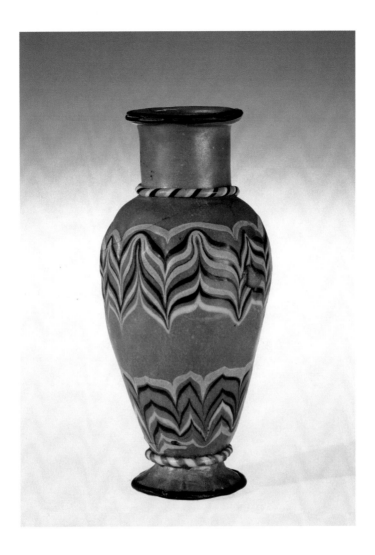

Vase

Egypt, 18th Dynasty,
about 1400–1300
B.C. H. 10.7 cm
(66.1.213).

The technique of core forming, which was introduced around the middle of the 16th century B.C., was used to fashion some of the first glass vessels. Core forming involves the application of glass to a removable core supported by a rod. There is no consensus about how this was accomplished. Some scholars believe that the glassmaker wound trails (strands) of molten glass around the core or dipped the core into molten glass. Others suggest that a paste of powdered glass was applied to the core and fused with heat. After forming, the object was removed from the rod and annealed (slowly cooled to room temperature). When the object had been annealed, the core was removed by scraping.

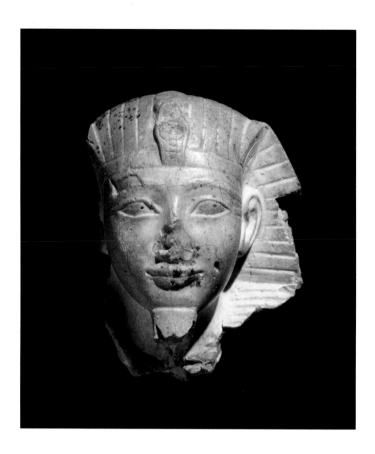

Portrait of an Egyptian king

Egypt, late 18th Dynasty, about 1450–1400 B.C. H. 4.0 cm (79.1.4).

Ancient glass sculpture is very rare. This is one of the earliest known glass portraits. It probably shows the head of Amenhotep II, who was ruler of Egypt about 60 years before Tutankhamen. The craft of glassmaking may have been introduced into Egypt during Amenhotep's reign. The head was carefully sculpted, probably with the simplest of tools and considerable effort on the part of the craftsman. Cast in blue glass, the sculpture is now tan in color due to its long burial. Several royal portrait heads in glass are known. They were probably made as parts of composite figures designed to incorporate other materials, such as gold, ivory, and wood.

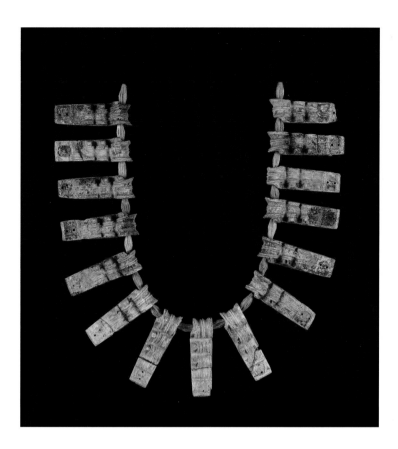

Necklace

Crete or southern
Greece, 1400–1250
B.C. L. (beads) 1.7–
2.0 cm (66.1.196).

During the late Bronze Age, glass was made in the Aegean region, especially in the Mycenaean Greek cities of Crete and the Peloponnesus. Characteristic of this production are beads, appliqués, and other small cast objects. The bright translucent colors of these objects are now often hidden beneath white or tan weathering crusts. The beads that were used to fashion this necklace or appliqué were made of deep blue and aquamarine glass. They were cast in open molds that were also employed by jewelers in the manufacture of identical gold beads. Such molds have been found in a variety of locations, suggesting that the making of beads was not a localized activity. The beads shown here are of the largest and most elaborate form made by the Mycenaeans. It is impossible to know whether the two colors of beads were strung in alternate patterns or if they came from two different necklaces or appliqués.

Vase

Assyria, 725–600 B.C. H. 19.0 cm (55.1.66).

Between 1200 and 1100 B.C., for reasons we do not fully understand, Bronze Age cultures in and around the eastern Mediterranean collapsed. Industries making luxury goods were among the first to vanish. Few glass objects dating between 1200 and 900 B.C. have been found. The manufacture of glass vessels resumed in the second half of the eighth century in Phoenicia and Assyria, where many glass table wares have been excavated at the sites of palaces. Cast monochrome cups, bowls, and vases were among the earliest Iron Age glass vessels. This vase and the famous Sargon vase in the British Museum belong to the early series of cast and cold-worked forms. The irregularity of the finishing on the Corning example, one of the most elaborate objects of its kind, indicates that it could not have been produced on a lathe—and that it was cut and polished by hand.

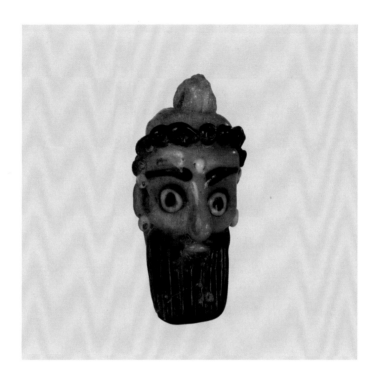

Pendant with bearded male head

Lebanon or Carthage, about 450–300 B.C. L. 5.7 cm (68.1.15).

From the seventh to third or second centuries B.C., a broad range of glass head pendants was produced. Traditionally, these objects have been attributed to Phoenician glassmakers, based on the large numbers of finds in or near that region. The pendants were made in such forms as bearded male heads, demonic masks, and rams' heads. Glassmakers wound hot glass around the end of a metal rod coated with a separating agent. Details were fashioned with blobs and trails of colored glass. A suspension ring was added at the top so that the pendants could be strung together as necklaces or used individually. At least 10 different types of heads are known, but the similarity of their manufacture suggests a common origin. Because these pendants were widely distributed, scholars are divided on where they were made.

Bowl

Western Asia, probably Iran, 500–400 B.C. D. (rim) 17.5 cm (59.1.578).

After the Assyrian kingdom was destroyed in 612 B.C., the casting of glass nearly disappeared. It was revived in the Achaemenid Empire during the fifth century. The Achaemenids were the rulers of Persia, and their glass industry focused on the manufacture of luxury table wares that imitated rock crystal. This type of broad, flat bowl, used for drinking or pouring libations, was widely used throughout the empire. The most luxurious of these objects were made of gold, rock crystal, silver, and glass. Fragments of two dozen cast and cut glass vessels, including a bowl of this kind, were found at Persepolis, one of the empire's capitals. It is not certain when they were made, but it must have been before the destruction of the palace complex by Alexander the Great in 331 B.C.

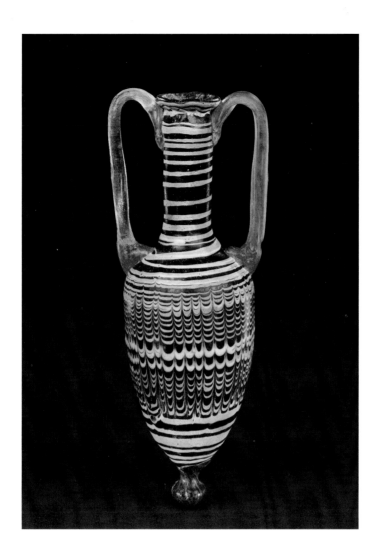

Jar with two handles

Eastern Mediterranean, possibly Cyprus, second–first century B.C. H. 24.0 cm (55.1.62).

Core-formed jars were manufactured in the Mediterranean region from the sixth century B.C. until about A.D. 10. Large numbers of these vessels have been found in the Syro-Palestinian region, and this has prompted some scholars to suggest that they were made there. Beginning in the mid-second century, large bowls of colorless or slightly colored glass were cast in this area, and similar glasses were employed to a limited extent in the production of some core-formed jars. Other scholars believe that Cyprus was the main source of these jars. While many of the jars made during this period are irregular in shape and poorly worked, this example reflects careful craftsmanship. It is decorated with trails in several colors, and it is also one of the largest jars of its kind.

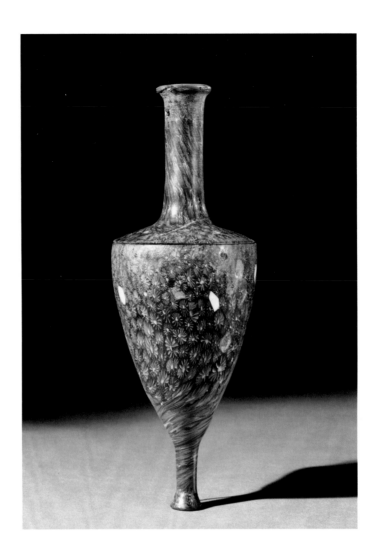

Jar

Probably eastern
Mediterranean, late
third–second century
B.C. H. 18.5 cm
(58.1.38).

Another notable achievement of Hellenistic glassmakers was the production of cast mosaic vessels with sections of preformed canes. A cane consists of thin, monochrome rods bundled together and fused to form a polychrome design that is visible when seen in cross section. It can be cut into slices that are arranged to form intricate patterns. Although earlier craftsmen had made glass mosaic inlays and plaques, the use of mosaic canes in the manufacture of vessels was virtually unknown until the late third century B.C. The jar shown here was made in two parts, presumably because it was difficult to fashion tall, narrow objects in mosaic glass. The opposed pairs of perforations in the upper neck and at the shoulder show that this object originally had two handles and was a miniature amphora.

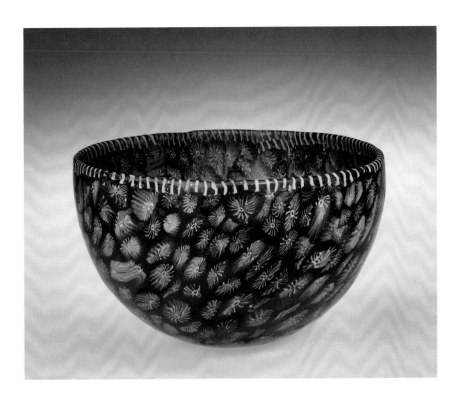

Mosaic glass bowl

Probably eastern Mediterranean, late second–first century B.C. D. 12.4 cm (55.1.2).

Perhaps the most famous Hellenistic mosaic glass vessels are hemispherical bowls made of polychrome canes with spiral or star designs. The bowls were probably formed by fusing slices of the canes into a disk and slumping the disk over a mold. Most of these objects have rims that were fashioned by spirally twisting threads of different colors to produce a striped effect. Later, this technique was employed in Roman workshops. The earliest of the Hellenistic hemispherical bowls may have been made in the second half of the third century B.C., but most were produced a century later. The source of these colorful bowls is unknown. They have been found in many locations, including Greece, Italy, Egypt, and Syria. Mosaic glass bowls were a typical product of glass workshops in the eastern Mediterranean, and this example may well have been made there.

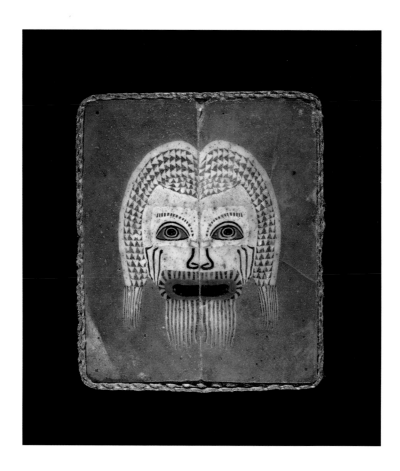

Plaque with actor's mask

Roman Empire, Egypt, possibly Alexandria, late first century B.C.–mid-first century A.D. H. 2.8 cm (66.1.78).

For three centuries following its conquest by Alexander in 332 B.C., Egypt was ruled by Macedonian Greeks. These rulers and their subjects enjoyed Greek drama. Troupes of actors presented performances in major towns throughout Egypt. Some of the most popular characters appeared in the comedies of the Athenian playwright Menander, whose plays remained popular long after his death. The actors employed conventionalized masks to represent these characters, and the distinctive colors and features of the masks made them instantly recognizable. The characters included soldiers, slaves, and courtesans, and they were portrayed in mosaic glass plaques that became popular decorative motifs. Glassmakers used halves of faces to form complete, symmetrical faces by combining two slices from the same cane, one of which was simply reversed. Here is one such mask, which shows Menander's brothel keeper.

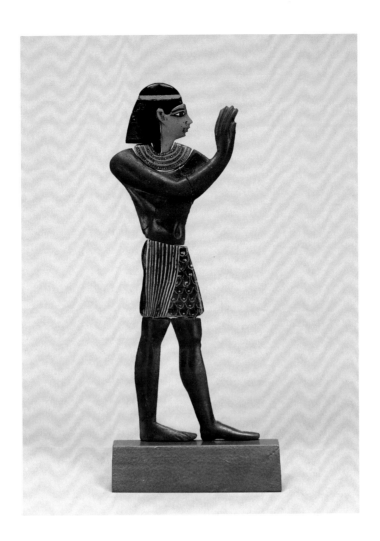

Inlay

Egypt, Ptolemaic,
third–first century
B.C. OH. 21.5 cm
(66.1.216).

The use of glass inlays to depict parts of human figures in decorative contexts began at least as early as the reign of Tutankhamen in the 14th century B.C. Although many parts exist, complete figures are relatively rare. The male figure shown here may be a composite, although the legs and torso do appear to be from the same figure. Unlike the earlier inlays, in which the various parts of the body were fitted into separate recesses, the wig, head, collar, torso, loincloth, and legs of the Corning figure—which dates to the last centuries of the pre-Christian era—were fitted together and originally held in place with an adhesive. This technique, developed by the Ptolemaic glass industry, coincided with the revival of gesso and plaster objects. Such inlays decorated wooden coffins, and they were also employed in household furnishings and religious shrines.

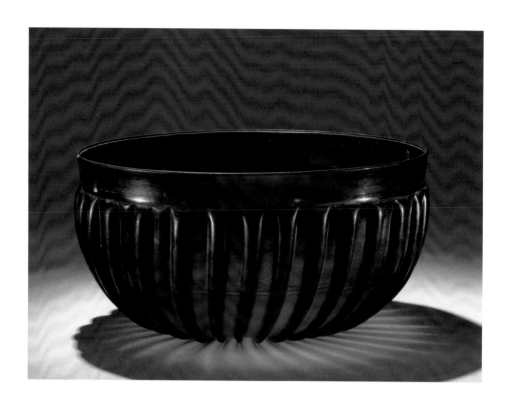

Bowl with ribs

Roman Empire,
about A.D. 50–75.
D. (rim) 19.8–20.0
cm (67.1.21). Gift
of Mrs. Joseph de F.
Junkin.

Among the earliest and most numerous types of glass produced by the Romans were cast monochrome vessels. In some stylistic and technical respects, Roman ribbed bowls are so similar to their Hellenistic precursors that the latter objects must have served as models for the former ones. Nevertheless, the Romans introduced some significant variations. They used brightly colored glasses, chiefly purple and blue. In addition, the ribs of these bowls are evenly spaced, producing symmetrical patterns. By the time of Augustus (r. 27 B.C.–A.D. 14), bowls of this type were used throughout the Mediterranean region, and they quickly spread to the northern provinces. They were also exported beyond the empire's eastern frontier. They have been found in Iran, Afghanistan, Pakistan, and India. Here is one of the largest known bowls from this period.

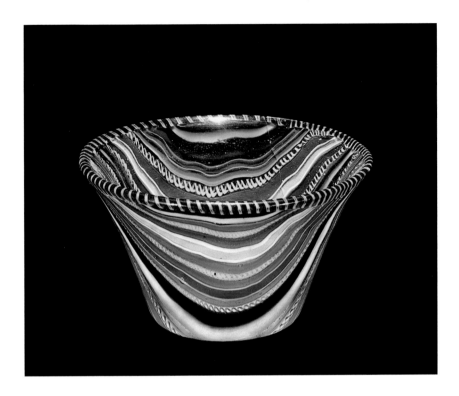

Ribbon glass cup

Roman Empire, about 25 B.C.–A.D. 50. D. 8.6 cm (72.1.11).

A new variety of mosaic glass was introduced in the first century B.C. It was "ribbon" mosaic, and the ornament consisted mainly of lengths (not slices) of canes arranged in geometric patterns. This concave-sided cup is a typical example. Many slices of just a few canes with different patterns were laid side by side on a flat surface and fused to form a disk. The disk was then placed on a convex mold and heated until the glass softened and slumped over the mold. The glassmaker then applied a softened spirally twisted cane to make the rim, and he finished the object by grinding and polishing. The fashion for brightly colored glass lasted until the mid-first century A.D., when colorless glass gained in popularity.

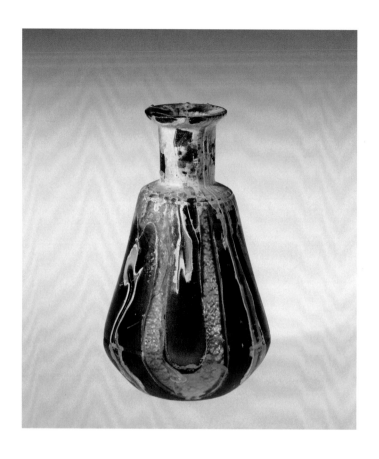

Gold-band bottle

Roman Empire,
about A.D. 1–50.
H. 7.3 cm (59.1.87).

Gold-band glass is the most elaborate and unusual variety of ribbon glass. Strips of gold foil were laminated between ribbons of colorless glass. Precisely how these vessels were formed is still uncertain. Perhaps groups of ribbons were fused in sinuous patterns, after which the fused elements were laid side by side in a mold, fused again, and shaped by tooling. We do know that, after annealing, the vessels were finished by grinding away irregularities. The most common types, miniature bottles and cylindrical boxes with lids, were produced in Italy during the first century A.D.

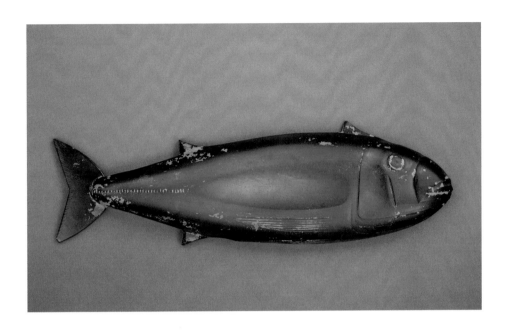

Cover in the form of a fish

Probably Italy, first century A.D. L. 33.7 cm (67.1.1).

Roman glassmakers sometimes produced objects in unexpected and highly original forms. This unique fish was cast in a mold. The upper surface was polished and wheel-cut with realistic (and anatomically correct) details, including the mouth, eye, gills, and fins. The underside is hollow, and the only "details" consist of groups of parallel cuts on the fins and tail. Clearly, only the upper surface was meant to be seen, and it is assumed that the object was a lid—the cover of a dish for serving fish. One lifted the glass fish (the cuts on the underside of the fins and tail would have made a firm grip possible) and found the real fish (about the size of a trout) resting on the dish.

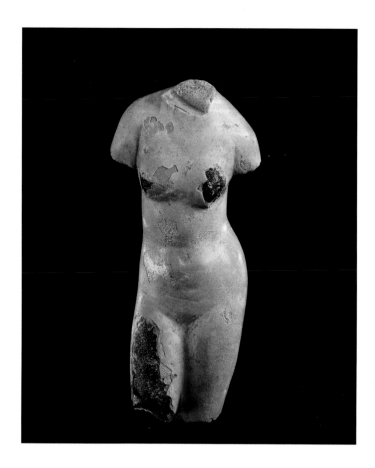

Statuette of Venus

Eastern Mediterranean or Italy, first–second century A.D. H. 9.4 cm (55.1.84).

This statuette of Venus is a rare example of Roman miniature sculpture in glass. It was probably cast by the "lost wax" technique, a method first used for casting metal. The object was modeled in wax, encased in clay or plaster, and heated. The wax melted and was released through vents that had been attached to the object before it was encased. The clay or plaster dried and became a mold into which molten or powdered glass was introduced through the vents. If powdered glass was used, the mold was heated to fuse the contents. After cooling, the object was removed from the mold, annealed, and finished by cutting. The statuette is a version of the Aphrodite of Knidos, a Greek life-size marble sculpture of the third century B.C., which was frequently copied by Roman artists. The fleshlike color of the surface is a happy accident—the result of weathering. When it was new, the object was yellowish green.

Glass of the Romans

The discovery of glassblowing during the Roman period made glass affordable and widely available for ordinary domestic purposes. However, the Romans also produced some of the most lavish luxury glass ever made. This gallery displays both the beauty and the versatility of the Roman glassmaker's art.

Between the first century B.C. and the fifth century A.D., Rome ruled a vast empire. At its peak, the Roman Empire stretched from the Atlantic Ocean to the Persian Gulf. The peoples of this empire included the most versatile glassmakers of the ancient world. They discovered glassblowing, and this enabled them to make low-cost glassware widely available. At the same time, they made stunning luxury items that included cage cups and cameo glasses.

In A.D. 326, Emperor Constantine I made Constantinople (modern Istanbul) the capital of the eastern Roman Empire. This new capital flourished for more than 1,000 years as the center of the Byzantine Empire. Early Byzantine glass includes mold-blown vessels decorated with Christian or Jewish symbols, which were made in Syria and the Holy Land.

Between A.D. 224 and 642, the Sasanians ruled an empire that extended from Rome's eastern frontier in Mesopotamia to Central Asia. Glassmaking thrived in the Sasanian Empire, and examples of Sasanian cut glass have been found as far afield as China and Japan. Beginning in the seventh century, the glassmakers of the Islamic world developed techniques inherited from craftsmen in the Byzantine and Sasanian Empires.

In western Europe, on the other hand, glassmaking declined after the Roman period. Fewer techniques were employed, fewer forms were produced, and the scale of production declined. Cage cups and cameo glasses ceased to be made, and decoration was confined to simple mold-blown patterns and trailed ornament.

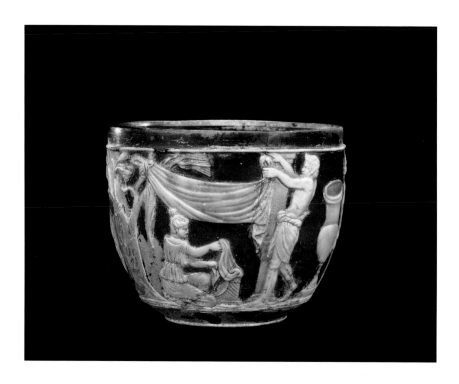

The Morgan Cup

First half of the first century A.D. H. 6.2 cm (52.1.93). Gift of Arthur A. Houghton Jr.

The rarest and most elaborate luxury vessels of the early Roman Empire are cameo glasses. These objects were inspired by relief-cut gems of banded semiprecious stones such as onyx. Glassmakers cased (covered) objects of one color with one or more layers of glass of different colors, opaque white on translucent deep blue being the most popular combination. The layered "blank" was given to a lapidary for carving, cutting, and polishing. The process required great skill and considerable time. This cameo vessel, the Morgan Cup (it was once owned by J. Pierpont Morgan), is decorated with a continuous frieze depicting a religious ceremony at a rural shrine. One side shows a female approaching a statue of Silenus. Women who wanted to become pregnant sometimes invoked the help of the god Dionysus, for whom Silenus, his tutor, here acts as proxy.

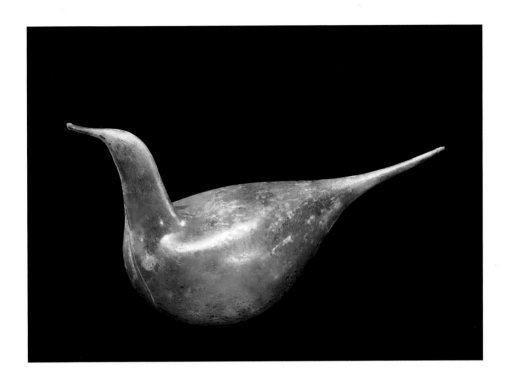

**Vessel shaped
like a bird**

First century A.D.
L. (including re-
stored tip of tail)
11.7 cm (66.1.223).

After the discovery of glass itself, the most significant in-
novation in preindustrial glassmaking was the discovery that
glass can be blown. This enabled glassmakers to produce ves-
sels much more rapidly than they could with the traditional
techniques of casting and core forming. They were also able
to make a greater variety of sizes and shapes. As a result,
glassware was no longer made exclusively for the luxury mar-
ket, and inexpensive objects became available for everyday
use. This vessel in the form of a bird is an unusual blown
object. In the 19th century, it was thought that vessels of this
type were open-ended and were used as wine tasters. Later,
it was realized that many of them were closed by fusing the
hollow tail, the tip of which had to be broken to remove the
contents. Some specimens have residues of white or red pow-
der, which may be cosmetic powder or perfume.

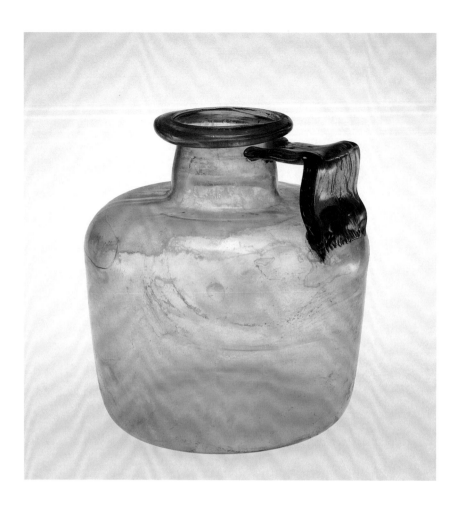

Bottle with handle

Late first–second century A.D. H. 30.2 cm (66.1.244).

Although glass vessels were never as cheap as earthenware, they had several advantages. They were easy to clean, they did not impart an odor to their contents, and they allowed one to see the contents even when the vessel was sealed. Thanks to glassblowing, the Romans were able to make large vessels for storing liquids and other perishable goods. Bottles with a broad cylindrical body and a wide strap handle were commonly used, especially in the western provinces of the Roman Empire. Examples have been found in Italy, the Rhineland, Belgium, France, and England. These finds suggest that the bottles came into use in the second quarter of the first century A.D. During the Flavian period (A.D. 69–117), square and cylindrical bottles were especially popular.

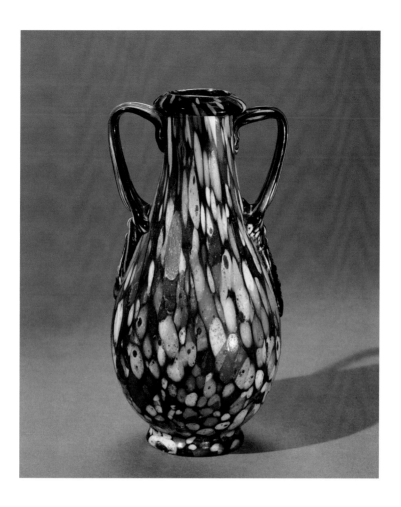

Jar with two handles

Probably about A.D. 50–75. H. 11.7 cm (59.1.88).

One early method of decorating blown vessels was by applying random fragments of colored glass to produce a speckled effect. This was achieved by reheating the partly formed vessel and either rolling it in loose fragments or dropping the fragments onto it. The glassmaker could then reheat it and roll it on a marver (in Roman times, probably a stone slab) until the fragments were flush. Further inflation would enlarge and distort the flattened fragments, giving the glass a multicolored appearance. This may have been an inexpensive means of imitating costly mosaic glass. Glass with a speckled surface seems to have been a specialty of northern Italian glasshouses in the first century A.D. The jar shown here was decorated by gathering molten glass on the blowpipe, rolling it in chips of colored glass, and blowing the glass to the desired size and shape.

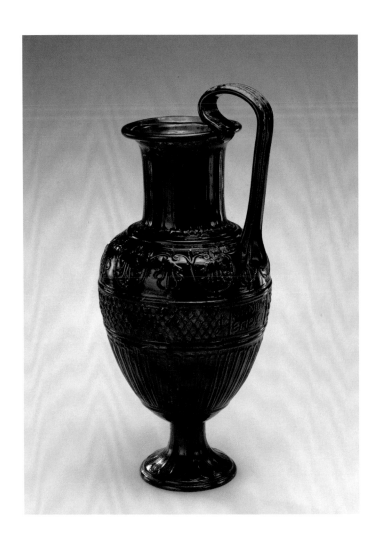

Ewer signed by Ennion

Mid-first century A.D. H. (including handle and restored foot) 23.8 cm (59.1.76).

The discovery that vessels can be formed and decorated by inflating a gob of glass in a mold permitted large numbers of virtually identical objects to be produced quickly and inexpensively. The first-century Roman writer Pliny believed that glassmaking had been invented at Sidon (in modern Lebanon), which in his day was still a famous center of production. For this reason, the earliest mold-blown vessels are frequently described as "Sidonian," although we cannot be sure if any were actually made there. The finest "Sidonian" vessels bear the signature of Ennion. The quality of the vessel depended on the quality of the mold in which it was blown. Ennion may have been a particularly skillful moldmaker, rather than the proprietor or gaffer (master craftsman) of a glassmaking workshop. On this ewer, the signature ("Ennion made [it]"), written in Greek, is in a panel beneath the handle.

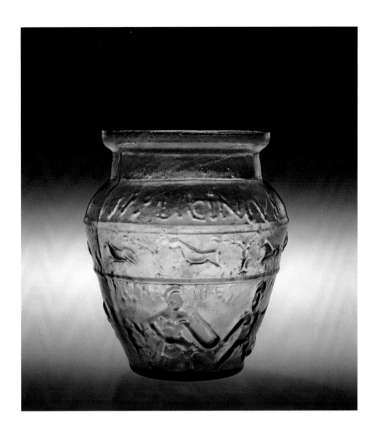

Sports cup depicting gladiators (signed by M. Licinius Diceus)

Second half of the first century A.D. H. 9.6 cm (57.1.4). Gift of Arthur A. Houghton Jr.

Early mold-blown glasses made in the western Roman Empire include cups and beakers depicting gladiatorial contests and chariot racing. These popular sports drew huge crowds to the amphitheater and the circus. "Sports cups" were blown in two-part molds and decorated with pairs of fighting gladiators or charioteers, identified by inscriptions. Unlike the sophisticated and often deliberately colored products of Ennion, sports cups are relatively crude and made of "natural" green or amber glass. Presumably, they were modestly priced and intended for the mass market. Although some of the gladiators are known to have fought in Italy, the distribution of the cups suggests that many were made in the western provinces. This also implies that the cups were not made to be sold as souvenirs at the events they depict, but to celebrate sporting heroes whom the purchasers may never have seen in action.

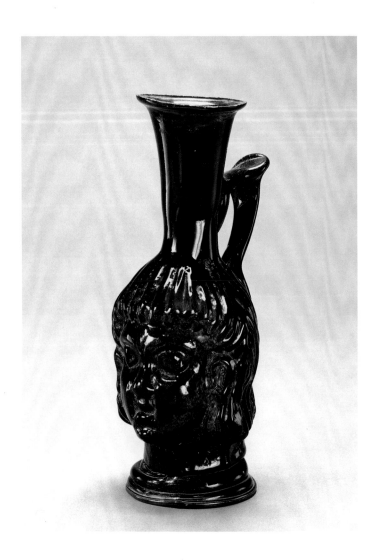

Head flask

Fourth–fifth century
A.D. H. 19.6 cm
(59.1.150).

After the mid-fourth century, glassmaking declined in the Roman Empire. In the east, where the decline was less pronounced, a group of deep blue flasks, pitchers, and lamps with coiled bases was produced. They seem to have been made in a single workshop, but examples have been found as far afield as the Sudan and South Korea. One member of the group is this head flask, which was blown in a two-part mold. The handle was applied to the neck, drawn out and down, and attached to the head. The remaining glass was dragged down to the neck and notched. The thumb-rest at the apex of the handle was made by pinching the hot glass with pincers. Only three other head flasks made from the same mold are known to exist. The Corning flask once belonged to the celebrated operatic tenor Enrico Caruso.

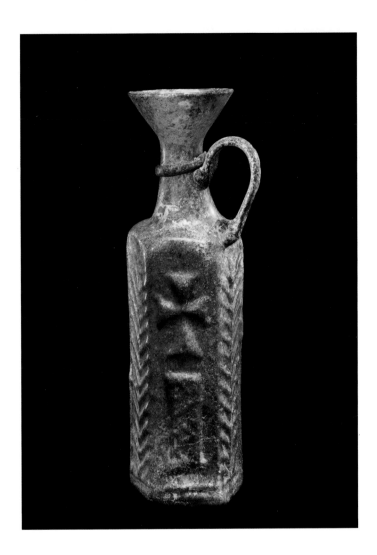

Pitcher with Christian symbols

Late sixth–early seventh century A.D. H. 21.7 cm (66.1.230).

Some of the most distinctive late Roman mold-blown vessels were made in Syria and Palestine. They are decorated with Christian or Jewish symbols, and many are believed to have been produced in or near Jerusalem. Most of these vessels are decorated with crosses, but the taller examples also have palm fronds and human figures on columns. The last motif suggests that the vessels were made in Syria, where pilgrims from as far away as Britain flocked to see Saint Simeon Stylites. Saint Simeon, expelled from his monastery for excessive austerity, spent the rest of his life perched on pillars (*stylites* is derived from the Greek word for "column"). Pitchers with stylite figures probably served as pilgrims' souvenirs. They may have contained oil or water from holy sites.

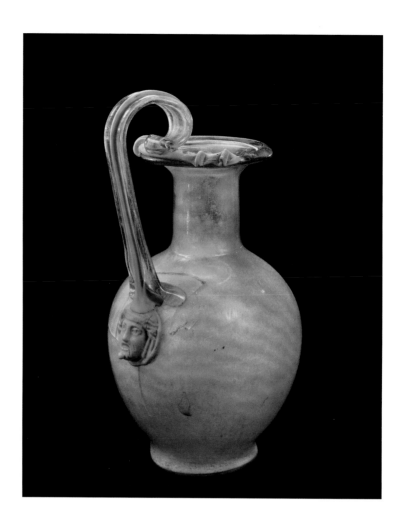

Pitcher with appliqué of a bacchant

About A.D. 50–75.
H. (including handle)
19.3 cm (66.1.41).

This vessel features, below the handle, an appliqué with the mask of a bacchant (a follower of Bacchus, the god of wine). Two methods of forming and attaching appliqués were employed in Europe during and after the Renaissance, and they probably were also used in Roman times. In the first method, the glassmaker slightly overfills a mold with molten glass. He then reheats the vessel and presses it against the excess glass. The glasses fuse, and the appliqué, now attached to the vessel, is withdrawn from the mold. The second method involves applying a blob of molten glass to the vessel and impressing it with a stamp. The larger the amount of molten glass, the greater the extent to which it softens and sometimes distorts the wall to which it is attached. For this reason, larger appliqués are usually molded and attached to the vessel after much of their heat has dissipated, while smaller appliqués are stamped.

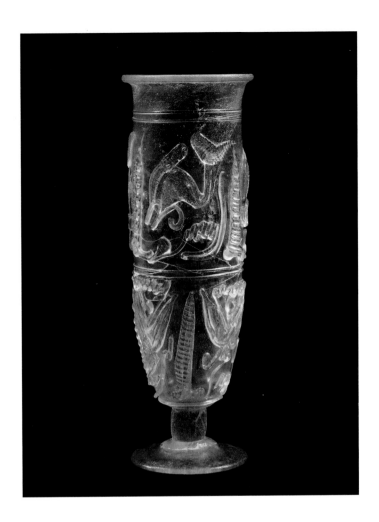

Beaker with dolphins

Late third–early fourth century A.D. H. 20.4 cm (82.1.1).

Glass is naturally green or amber in color because of impurities (mainly iron) in its principal ingredient, sand or crushed quartzite. Coloring agents (such as cobalt, which produces blue) can change the color of glass, and decolorants can remove the natural color. Chemical analyses have shown that the Romans sometimes used antimony or manganese to decolorize glass. Colorless glass had been produced in Hellenistic times, but it did not become popular until the second half of the first century A.D. This almost colorless beaker was decorated by trailing. Trails of molten glass were dropped onto the surface of the reheated vessel and then drawn out and tooled to produce a pattern of dolphins and water plants. Even after colorless glass had gained favor, it dominated only the upper end of the market. The simplest utilitarian products were still made in naturally colored glass.

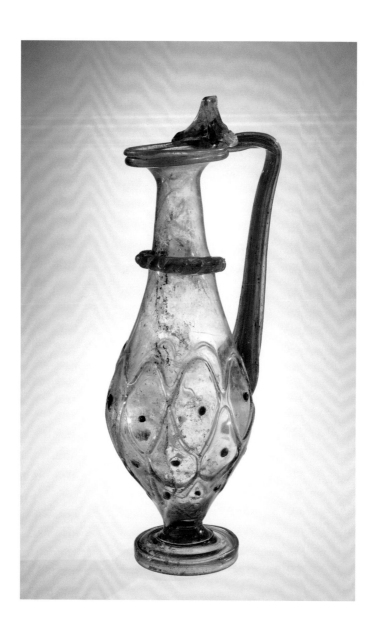

Pitcher

Fourth century A.D.
H. 42.5 cm (64.1.18).

This unusually large pear-shaped pitcher with trailed and blobbed decoration was made in the eastern Mediterranean in the fourth century A.D. It was decorated in the following manner: A thick horizontal trail was applied to the neck and nicked with a rod or a pair of pincers. Three vertical zigzag trails were applied to the body and nipped together in a diamond pattern. A small blue blob was applied at the center of each diamond-shaped compartment and in each triangular space below the lowest row of diamonds. The final stage in the manufacturing process was the attachment of the handle.

Cosmetic tube with four compartments

Fifth century A.D.
OH. 39.0 cm
(54.1.100).

This cosmetic tube with four compartments is one of the largest and most elaborate objects of its kind. Presumably, it was intended for display, since the complex superstructure makes it virtually unusable as a container. The compartments were made by pinching a tubular parison (gob of glass) vertically to form diaphragms. The wall was decorated by attaching a trail to the side of each compartment just above the base and drawing it up to the rim in eight folds. Each of these four trails was then covered by another trail, which was attached to the lip, pulled down over the entire length of the folds, and pinched in a series of horizontal projections.

**Beaker
with faceted
decoration**

Late first–early sec-
ond century A.D. H.
14.8 cm (59.1.129).

Roman glassworkers sometimes finished their products by cutting, grinding, and polishing. They had learned these techniques from lapidaries, who employed them in completing works made of semiprecious stone. Very little is known about the tools used in this process, although the Roman writer Pliny provides some information about the working of semiprecious stones with abrasives. The same abrasives were probably also used in the cold-working of glass. Indeed, it is likely that some craftsmen worked with both materials. Some of the glass objects finished by cutting, engraving, and wheel abrading featured faceted decoration. One of them was a conical beaker with 11 rows of mostly diamond-shaped facets made by grinding and polishing. Similar beakers have been found all over the Roman Empire, in Scandinavia, and in Afghanistan.

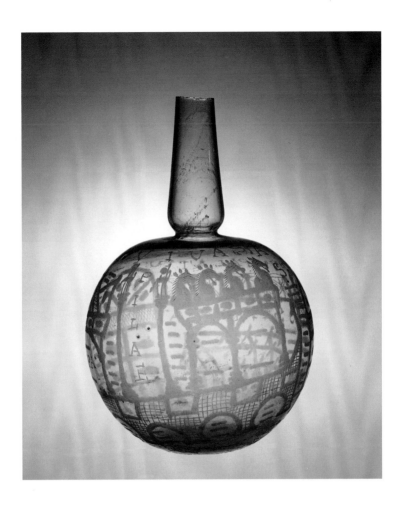

The Populonia Bottle

Late third–early
fourth century A.D.
H. 18.4 cm (62.1.31).

Roman glassmakers normally polished their cut decoration. On some occasions, however, they left these areas rough to create a contrast between the granular surface of the decoration and the smooth surface of the background. This is known as abrasion. The Populonia Bottle is an outstanding example of late Roman abraded decoration. It is one of a group of nine similarly shaped vessels decorated with waterfront scenes and inscriptions. The scenes on some of these vessels depict a lake, a palace, an oyster bed, a jetty, and columns. The inscriptions identify the setting as *Baiae*, a Roman harbor town and resort on the Bay of Naples. The Populonia Bottle shows famous buildings in and around *Baiae*. Its name records the findspot, *Populonia* (near modern Piombino) in Tuscany, where it was discovered about 1812.

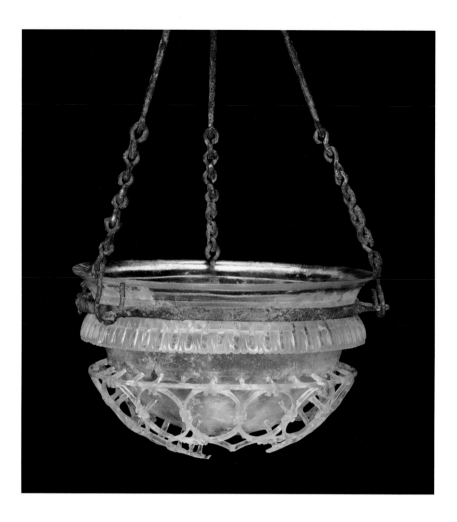

Cage cup

Early fourth century
A.D. D. 12.1 cm
(87.1.1). Arthur
Rubloff Residuary
Trust.

Cage cups are the most exclusive luxury glasses made in the later Roman Empire. They date from about A.D. 250 to the mid-fourth century. Cutting and grinding a single thick-walled blank was a laborious and risky process. If just one mesh of the cage was broken, the entire vessel had to be scrapped. For this reason, cage cups were exceptional objects. They were often owned by the most privileged members of Roman society. Some cage cups are shaped like beakers and inscribed with toasts such as "Drink! May you live for many years!" Others, including the example shown here, are shaped like bowls. The metal fittings indicate that this object was meant to be suspended. It is possible that bowl-shaped cage cups were hanging lamps rather than drinking vessels.

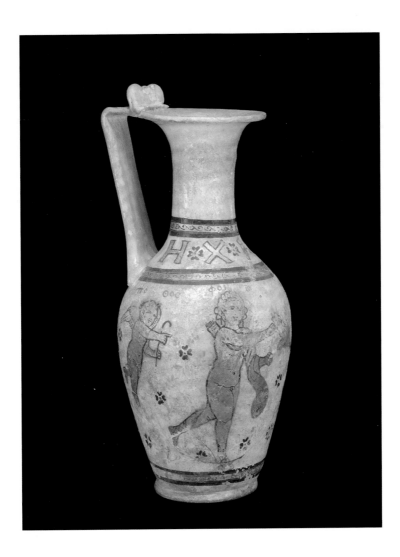

The Daphne Ewer

Late second–early third century A.D.
H. 22.2 cm (55.1.86).

The Romans used two kinds of painted decoration on glass. In the first kind, known as cold painting, the surface is covered with watercolor, tempera, or oil paint. In the second kind, the "paint," made from powdered glass, is fused to the surface of the object by heating it in a furnace. This more permanent technique is called enameling. The Daphne Ewer was decorated with cold painting and gilding. It depicts a scene from Greek mythology. The nymph Daphne, daughter of the river god Ladon, resisted her father's entreaties to take a husband. The god Apollo, wounded by an arrow of Desire, saw Daphne and fell in love with her. She fled from him and, almost exhausted by the chase, called out to her father to rescue her. As Apollo reached out to embrace her, she was transformed into a laurel tree.

41

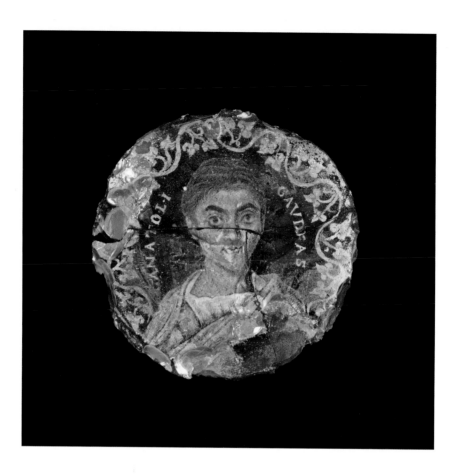

**Medallion
with portrait**

Third century A.D.
D. 4.9 cm (90.1.3).
Purchased with
the assistance of
the Clara S. Peck
Endowment.

Gold glasses are objects decorated with gold sandwiched between two fused layers of glass. Roman glassmakers applied the gold as foil, which was usually decorated by removing unwanted areas and adding scratched or painted details. Most Roman gold glasses were made in the third and fourth centuries. One form was the medallion, a small, circular object that generally consisted of a deep blue disk and a colorless cover glass. Most of these medallions have portraits, which are sometimes accompanied by Greek or Latin inscriptions. This example bears the Latin inscription "ANATOLI GAVDIAS" (Anatolius, rejoice!). Although the inscription wishes joy to a man, the medallion is decorated with the portrait of a woman drawn and painted on gold foil. Perhaps she was his wife or close companion and gave the medallion to him as a gift.

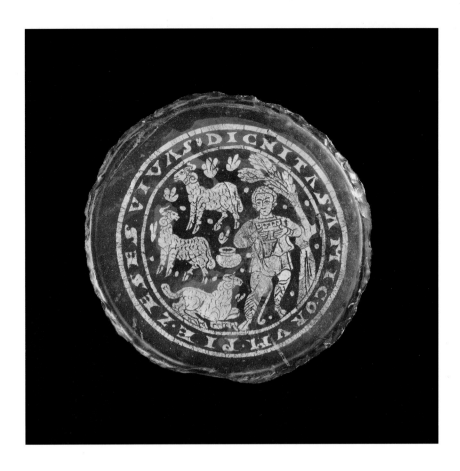

Gold-glass fragment with shepherd and flock

Fourth century A.D.
D. 9.7 cm (66.1.37).

Gold glasses were used in a variety of ways. In addition to medallions bearing portraits, they were made as roundels at the center of dishes and bowls. This example shows a shepherd tending his flock. The Latin inscriptions surrounding the scene are drinkers' toasts that may be translated, "[Be] the pride of your friends; drink that you may live; may you live." The shepherd and flock motif might initially incline the viewer to think that the inscription is a Christian exhortation. However, the shepherd is holding a panpipe, which is not a Christian symbol, and thus the medallion probably depicts a bucolic scene with no religious significance. Roundels similar to this one were displayed beside tombs in the catacombs, the underground galleries used by Jews and Christians for burying their dead.

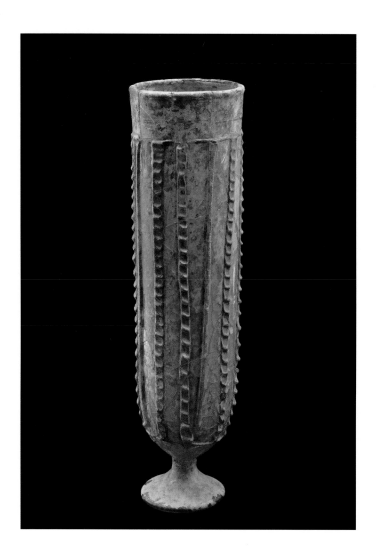

Flute

Sasanian, probably
about fourth century
A.D. H. 28.4 cm
(70.1.6).

Beyond Rome's eastern frontier lay the territory of the Sasanians, a dynasty that originated in southern Iran. Between the early third and mid-seventh centuries, the Sasanians ruled a vast empire that extended from Mesopotamia to parts of Central Asia. Some Sasanian glass was similar in form and decoration to Roman production, but other pieces were inspired by a specifically Iranian style. The Roman influence can be seen in this Sasanian flute. It has a narrow cylindrical pale green body, a plain rim that was rounded at the furnace, and trailed decoration in two colors. The best-known Roman parallels for this object include two flutes made in Sedeinga in the Sudan. These colorless, wheel-cut vessels were discovered in a tomb attributed to the second half of the third century A.D. It is assumed that they were made in Egypt.

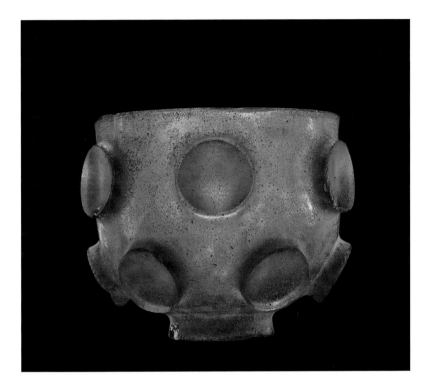

Bowl

Sasanian, Iran, perhaps sixth–seventh century A.D. D. 8.1 cm (72.1.21).

Another example of Sasanian craftsmanship is a small bowl cut with relief bosses. It was probably made in Iran. The surfaces of the bosses are concave. The surrounding glass has been cut back to leave the bosses standing in relief, a process that would have required a great deal of effort. The foot of the bowl has been treated in the same way. Similar objects were among the Sasanian glassware exported to the Far East. At least one example is known from China, and fragments of another were found in a sixth- to seventh-century context on the Japanese island of Okinoshima.

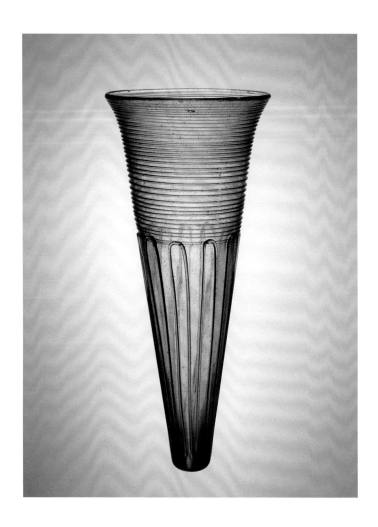

Cone beaker

Frankish, mid-fifth–
sixth century A.D. H.
23.2 cm (66.1.247).

When the Roman Empire collapsed, tastes in glass changed. In areas dominated by the Franks, simpler shapes and decorative styles prevailed. Cutting, engraving, and enameling disappeared. The most sophisticated techniques that survived were performed at the furnace. A cone beaker demonstrates that unsophisticated techniques can produce outstanding results. The horizontal trailing below the rim and the looped threading toward the bottom provide a contrast that complements the form of the glass, which rises sharply from a narrow base and then spreads out gradually toward the top. This object was found in England, but the quality of its workmanship and the find-places of similar pieces show that it was made in Germany or the Low Countries. The form of the cone beaker probably reflects Frankish drinking habits. An emptied glass was immediately taken from the guest and refilled. It often had a vestigial foot—or no foot at all.

Glass in the Islamic World

Glassmaking flourished in Egypt and the Middle East at the time of the Arab conquest in the seventh century. Later, Islamic glassmakers developed new forms and types of ornament. They also revived or rediscovered ancient techniques, and they discovered at least one new technique: staining.

Decorators stained glass in a variety of colors, which are often described as "luster." First, they painted the surface with a paste containing copper and/or silver. Then they fired the glass in oxygen-free conditions at about 600°C, thereby fixing the metallic colors.

Among the other techniques used in the Islamic world were:

Mosaic glass. Glassworkers produced patterned canes, which were cut into slices, arranged in the desired shape, and heated until they fused. This technique was used in the Islamic world for a short period in the ninth and 10th centuries.

Cutting and engraving. Islamic workshops created large quantities of cut and engraved glass. Relief cutting in particular was highly developed in the Islamic world in the ninth and 10th centuries. The design was drawn on a blank, and the background was removed to leave the ornament standing in relief. The interior of the relief was also cut away so that the decoration appeared as an outline. Most relief-cut glass was colorless, in imitation of rock crystal.

Trailing. Trailed decoration was employed by Islamic glassworkers throughout the Middle Ages. In one of the most distinctive types of glass made in Egypt and the Near East in the 11th and 12th centuries, the trails were tooled into featherlike designs and then rolled on a marver until they became flat.

Mold blowing. By inflating glass in decorated molds, glassworkers could produce decorated objects almost as quickly as plain ones. Decorations ranged from geometric patterns to birds, animals, and inscriptions.

Gilding and enameling. The richly gilded and enameled glasses of the late 12th to 15th centuries are among the greatest achievements of Islamic glassmakers. After the objects had cooled, they were painted with gold and enamel. They were then reheated to fuse the decoration to the surface.

In addition to discovering glass staining, Islamic craftsmen made improvements in a number of techniques that had been used to produce glass in the ancient world.

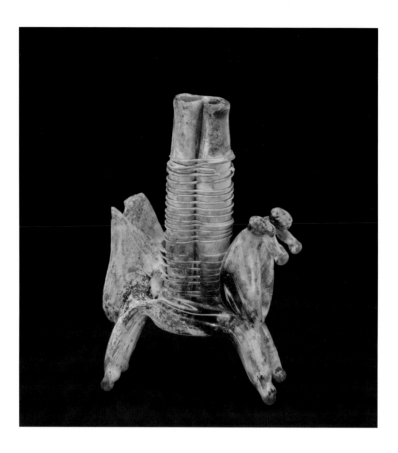

Double cosmetic tube

Near East, possibly Syria, about sixth–eighth century. H. 11.3 cm (55.1.109).

Glassmaking was one of many crafts that flourished in the Sasanian Empire, and numerous products have come to light. Unfortunately, because our knowledge of Sasanian glass is somewhat limited, we cannot be sure whether some of these objects are Sasanian, Byzantine, or early Islamic. One example is this double cosmetic tube supported by two horses. It had both functional and decorative uses. Tubular containers for cosmetics mounted on zoomorphic figures were made in the Syrian region. The idea of supporting small containers with animal forms may have derived from the production of glass toys and figurines. More than 20 such objects are found in museums around the world. Some of the tubes are surrounded by an openwork "cage" made with trails of molten glass.

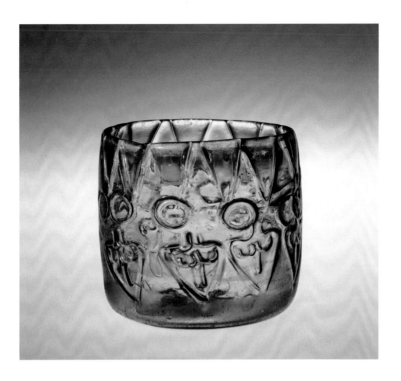

Cup with pinched decoration

Egypt, Syria, or Iraq, ninth century. H. 8.3 cm (55.1.17).

This cup belongs to a large group of early Islamic vessels that were decorated by pinching the surface with tongs. The metal tongs had circular or square ends containing the carved motif that was to be impressed in relief on the wall of the glass. Three different pairs of tongs, which produced triangular, circular, and heart-shaped patterns, were used to decorate the Corning cup. The makers of such objects may have been seeking ways to achieve some freedom of expression within the rules of repetition common in Islamic art. This freedom could be achieved by using different combinations of tongs, which bore patterns different from those of one- or two-part molds. Archeological finds indicate that this type of glass was traded extensively in the Islamic world during the ninth and 10th centuries.

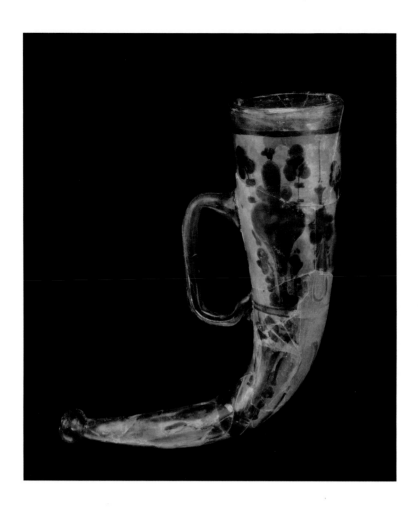

Drinking horn

Probably Egypt,
eighth–ninth century.
L. 21.5 cm (69.1.4).

The first painters of glass in the Islamic world applied a brownish or yellowish metallic pigment on bowls, dishes, and other objects. The decoration usually consists of animal or vegetal motifs, sometimes accompanied by inscriptions. By applying pigments to both sides of these objects, glassmakers could highlight details or exploit the transparency of the glass to produce subtle shading effects. This object is a drinking horn with a large applied handle. Its shape is obviously derived from the use of animals' horns for drinking. Glass horns were made by the Romans in the first century A.D., and horns of silver and ivory had been created by Achaemenian and Parthian artists in Iran before that time. However, in the Islamic world, such vessels never became popular in any medium. Only three Islamic glass horns are known, and this is the earliest example.

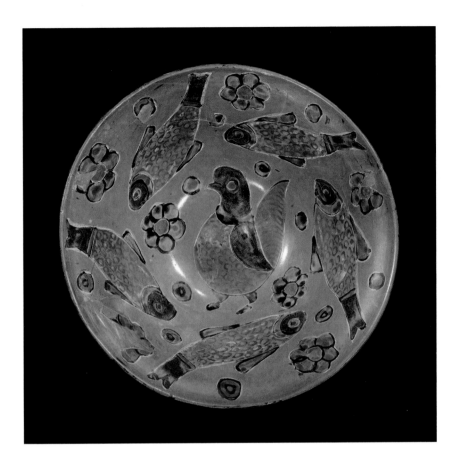

Bowl

Egypt, ninth century.
D. (at rim) 15.8 cm
(99.1.1). Gift of
Lyuba and Ernesto
Wolf.

In the ninth and 10th centuries, Islamic glassmakers introduced new shapes, colors, and decorative patterns. This is among the most extraordinary stained glass objects that have survived from the Islamic period. The decoration focuses on a small, plump bird, perhaps a partridge or pigeon, surrounded by five fish. The entire surface of the bowl appears to have been coated with a copper-rich purple-red film before the decoration was drawn. The surface has a pale brown cast under reflected light, but the almost colorless glass, the coating, and the colorful stain come to life under transmitted light. The blue effect was not part of the design. Instead, it is due to weathering.

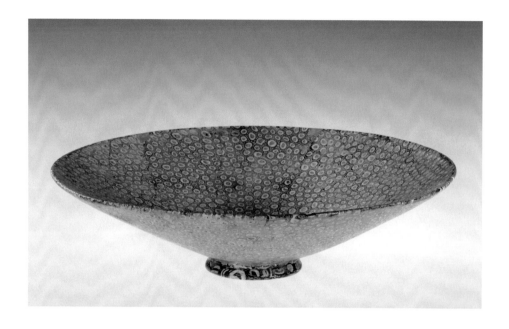

Bowl

Western Asia, ninth–
10th century. D. 20.2
cm (79.1.2).

The discovery of fragments of mosaic glass vessels and tiles in the ruins of a caliph's palace built in 836–842 at Samarra (Iraq) indicates that some Islamic mosaic glass was made in the ninth century. It is not known when this production began or ended. With the possible exception of beads, there is no evidence of Sasanian or Roman mosaic glass manufacture after the fourth century. This seems to suggest that the mosaic glassmaking technique may have been rediscovered by Islamic craftsmen. Although little mosaic glass appears to have been produced in the Islamic world, it was nevertheless widely distributed, from Egypt to Iran. This restored bowl is made of cane slices with an opaque yellow circle at the center, surrounded by an opaque white ring and a ring of small white spots in a "black" matrix. When complete, the wall and floor of the vessel would have contained some 1,300 slices.

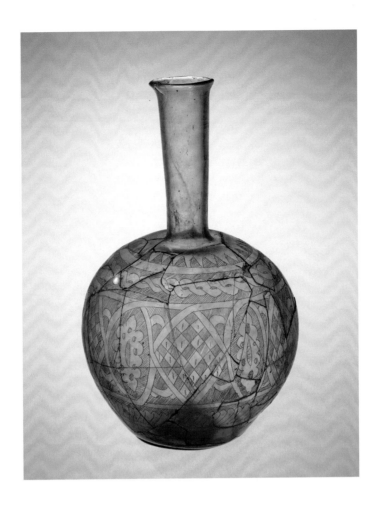

Bottle with scratch-engraved decoration

Syro-Palestinian region or Egypt, ninth century. H. 20.7 cm (68.1.1).

In the simplest form of Islamic engraving, the surface of the glass was scratched with a pointed tool. Often, the entire surface of an object was covered with decoration. Some patterns were simple and quickly executed, while others were complex and painstakingly rendered. Inscriptions are found on a number of these objects, but none has been useful in dating them. Therefore, their chronology has been based on archeological finds. Fragments of Islamic scratch-engraved glass have been excavated at two eighth-century sites: Susa (southwestern Iran) and Beth Shean (Israel). The finds from ninth-century contexts have been more numerous, and the closest parallels are six deep blue plates from a Chinese temple crypt that was sealed in 874. This bottle is decorated with four continuous horizontal bands of scratch-engraved ornament. Chemical analysis has shown that the glass was made with natron, which suggests that it came from Egypt or the Syro-Palestinian region.

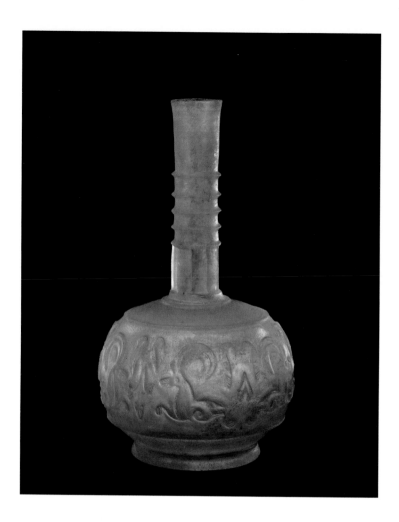

Bottle with relief-cut decoration of ibexes

Western Asia, probably Iran, ninth–10th century. H. 16.7 cm (71.1.7).

There are many Islamic relief-cut glasses. Some are monochrome (usually colorless, in imitation of rock crystal), and others are cameo glasses. On all of these objects, however, the background and most of the interior of the main decorative motifs were removed by cutting and grinding, leaving the outlines and a few details in relief. In the ninth and 10th centuries, these objects were widely distributed in the central part of the Islamic world. A wide variety of decorative images was used: palmettes, horses, hares, lions, birds, and even fantastic animals. The bottle shown here is decorated with a broad frieze that contains three pairs of ibexes facing one another across a vegetal motif. The cutting is careful and detailed, even on the inside of the rim and the underside of the base—areas that were not normally visible on such objects.

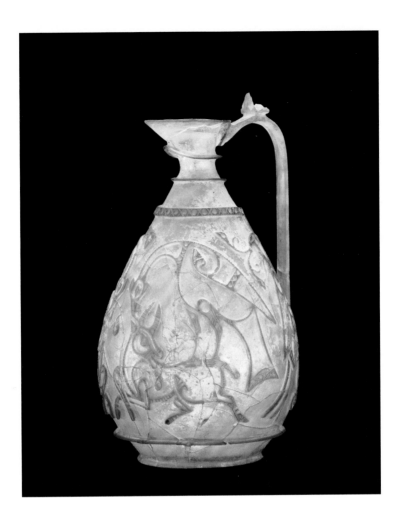

The Corning Ewer

Western Asia or Egypt, about 1000. H. (at rim) 16.0 cm (85.1.1). Clara S. Peck Endowment.

The Corning Ewer is an outstanding example of Islamic relief-cut cameo glass. A layer of transparent light green glass was applied to a layer of colorless glass. Most of the outer layer was then cut away, leaving the decoration in relief. Although the Romans made cameo glass, scholars believe that this technique did not continue into the Islamic period. It was probably rediscovered in Western Asia or Egypt in the ninth century. The decoration of the Corning Ewer shows two opposed horned animals with crossed forelegs, each of which has a bird of prey perched on its rump and pecking at the back of its neck. At the edges of the panel are two parrot-like birds standing on foliage. What makes this design of unparalleled elegance and subtlety even more distinctive is that it was accomplished on walls of eggshell thinness.

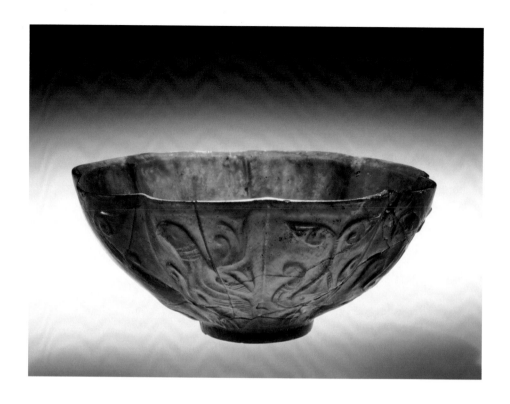

Bowl with relief and slant cutting

Western Asia, perhaps Iran, ninth–10th century. H. 7.6 cm (55.1.136).

Many early Islamic wheel-cut objects were decorated in a style that was also used to carve stucco, stone, and wood at Samarra in the ninth century. This style, which used to be called "beveled," is now known as "slant-cut." The surface was cut and ground so that, in cross section, it looks like a check mark. This afforded the ornament a raised appearance. Fragments of slant-cut glass, dated to the ninth or 10th century, have been found at Samarra. This bowl displays a combination of relief and slant cutting. The two principal motifs —a standing bird with a small head and an elongated body, and a tree of life—appear four times. Presumably the bowl was fashioned from a glass disk that was sagged over a mold, then cut, ground, and polished.

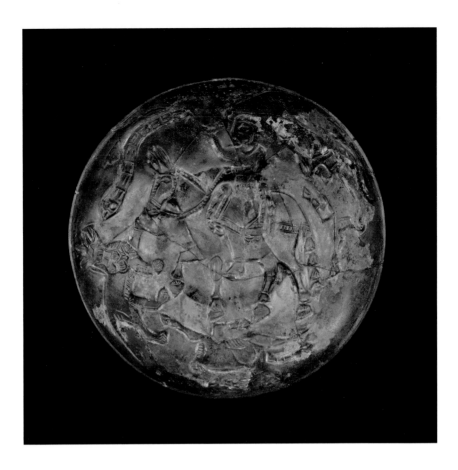

**Dish with rider
and animals**

Probably Iran, 10th–
11th century. D. 25.0
cm (55.1.139).

Like the bowl described on the facing page, this dish was
made by sagging a disk of molten glass over a decorated mold
and, after annealing, by cutting it on the wheel. The style of
the cutting is unusual. The figures stand in relief of uniform
thickness, without raised borders. The decoration shows a
mule and rider surrounded by four animals: two ibexes, a lion
with a prominent mane, and a snake. This scene is similar to
those found on Sasanian-period metal dishes decorated with
riders. The riders on the metal dishes are usually kings (iden-
tifiable by their distinctive crowns), armed and mounted on
horses with rich trappings. They are shown hunting lions,
boars, or other animals. Here, by contrast, the rider has no
weapons, rides a mule, and pays no attention to the four ani-
mals surrounding him. This indicates that the dish is not Sa-
sanian, and scholars conclude that it was made in the early
Islamic period.

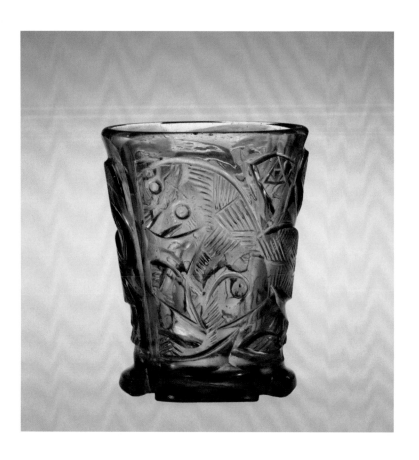

Hedwig beaker

Origin unknown,
probably 12th–13th
century. H. 8.7 cm
(67.1.11).

This is a typical example of a puzzling group of glasses known as Hedwig beakers. They are unlike any other medieval objects of glass or rock crystal from the Islamic world, Byzantium, or western Christendom. These colorless or nearly colorless glasses are decorated in slant-cut relief with a variety of motifs, including lions, eagles, griffins, and the tree of life. The group is named after Saint Hedwig of Silesia (d. 1243), who is traditionally associated with three of the beakers. Most of the complete Hedwig beakers were found in church treasuries, and fragments of six others were uncovered at archeological sites, all in Europe. The earliest datable examples belong to the 12th or early 13th century. Scholars have argued variously that the beakers were made in the medieval Islamic world, Byzantium, and southern Italy. However, there is no decisive evidence in favor of any one of these locations.

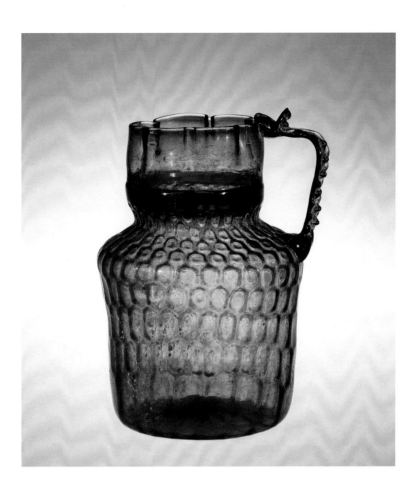

Pitcher with inscription

Iran, 12th–14th century. H. (at thumb-rest) 16.2 cm (66.1.5).

This pitcher was decorated by inflating molten glass in a mold. Since glassmaking molds were introduced by the Romans in the early first century A.D., they have been used continuously in Egypt, Western Asia, and elsewhere. No examples of full-size metal molds from the medieval Islamic period are known to exist, but the Corning collection contains one of two surviving metal dip molds. It has an overall pattern of lozenges, and it bears a scratched inscription that gives the name and occupation of the owner: "Uthman b. Abu Nasr, glassmaker." The body of the pitcher was blown in a similar dip mold, withdrawn, and inflated further. The neck was tooled, and the handle was applied and pinched. This type of colored mold-blown glass is often attributed to the Gurgan region of northeastern Iran.

Flask

Probably Egypt,
11th–12th century.
H. 14.6 cm (50.1.32).

Small cosmetic flasks are among the most common Islamic glass vessels with marvered decoration. They may have held kohl (a powder used to darken the eyelids or eyebrows) or unguents. Here is one of the best examples of its kind. It features white trails that were tooled into a festooned pattern covering the entire surface, then marvered until the trails were flush with the surface. Such vessels are sometimes called "spear" flasks because of their slender, flared profile and small base. Their shape suggests that they were stored horizontally or at a slight angle, or that a support was used to keep them upright. The traditional association of these objects with cosmetics was recently verified by the discovery of a small flask at al-Tur, on the Sinai Peninsula, that still retained some kohl. It was found next to a copper rod that was used to apply the compound to the eyelids.

Handled vase

Egypt or Syria, about
1310–1330. H. 30.2
cm (55.1.36).

Enameled and gilded glass is the most celebrated type of glass from the Islamic world. During the 13th and 14th centuries, in a region that now includes Egypt and Syria, Ayyubid and Mamluk glassmakers lavished their creative efforts on generously proportioned and richly painted objects. The shape of this handled vase and its parallels is unknown in Mamluk metal and ceramic production, and it has been suggested that the glassmakers were inspired by Chinese ceramic vases with dragon handles. The decorative composition of the vase is particularly well balanced. It consists of lively schools of fish at the top and bottom, a prominent inscription, a heraldic six-petaled rosette, and staggered circular medallions that enlarge proportionally with the body of the object. The rosette has been interpreted as the emblem of several Mamluk emirs.

Candlestick

Probably Egypt,
about 1340–1365.
H. 22.2 cm (90.1.1).
Clara S. Peck En-
dowment.

Only two enameled and gilded glass candlesticks from the Islamic world are known. Here is one of them. The shape derives from Islamic metalwork. (Bronze candlesticks are relatively common.) The polychrome enamels and the gilding cover so much of the surface that the underlying honey-colored glass is barely visible. The main geometric pattern, consisting of elongated hexagons and five-pointed stars, was widely used in Mamluk art of the late 14th and 15th centuries. The inscription is translated, "Glory to our lord, the sovereign, the learned, the just, the holy warrior, the defender, the protector of the frontiers, the fortified [by Allah], the triumphant, the victorious." There is no doubt that this object was dedicated to a Mamluk sultan, but scholars are not sure which one.

Early European Glass

During the Middle Ages, rural glasshouses all over Europe produced glass for daily use. Monasteries, the leading centers of learning at that time, may have helped to preserve the glass-making traditions of antiquity. From the 12th century, the interiors of Gothic churches were illuminated with large stained glass windows. These windows were often designed by artists as a narrative series.

The glasshouses of central and northern Europe produced tableware, storage containers, and windowpanes. Some of this glass, which was mixed with potash made from the ashes of trees or ferns, was called *Waldglas* (forest glass). Its green color comes from the iron impurities in the sand from which it was made.

Northern European glass of the 16th century was made in various sizes and shapes. Colors ranged from shades of green to perfectly colorless. Most of this glass was sturdy and practical. Decorations, which were usually simple, included trails, prunts (applied blobs of glass), and inscriptions. Some glass-blowers expressed their sense of humor in trick glasses and other complicated forms.

During the Renaissance, luxury glassmaking flourished, especially in Italy. By the mid-15th century, Venetian glass-blowers on the island of Murano made *cristallo*, a thin, colorless glass that resembled rock crystal. They also sought to imitate other hard stones, such as chalcedony and opal, and Chinese porcelain.

Venetian glass shapes of the 15th century were indebted to medieval forms. By the 16th century, Venetian glassmakers had distilled the knowledge and honed the skills that had continued to be practiced over the years. Their elaborate tableware, mirrors, and lamps were sold throughout Europe and the Islamic East. Strict laws regulated the exportation of raw materials and technical knowledge.

However, some Venetian glassmakers were allowed to travel during the *cavata* (mid-August through January), when furnaces were shut down. A number of Muranese craftsmen moved to other cities in Italy and elsewhere. These skilled workers introduced the making of filigree glass, tooled dragon stems, and ice glass to foreign glasshouses, which often combined Venetian techniques with local forms and decorations.

**Tall beaker
(*Knotsbeker*)**

Southern Netherlands or northern France, about 1500. H. 25.6 cm (2000.3.23).

Some of the drinking glasses made in northern forest glasshouses were large and elaborate. The *Knotsbeker* is a variation of the *Keulenglas* (club-shaped beaker), a straight-sided vessel with a bulging wall that narrows slightly near the rim. The largest of these glasses were 30 to 50 centimeters tall and held half a liter of beer. Smaller examples were used for wine. Such glasses were popular during the second half of the 15th century, but they had disappeared before the end of the 16th century. The *Knotsbeker* illustrated here is an extremely rare and luxurious form of forest glass. Beakers of this type, but without the trailed collar around the stem, have been found in the Netherlands and northern France.

Panel with the arms of Escher vom Glas

Switzerland, probably Zurich, workshop of Lukas Zeiner, 1500–1510. H. 38.9 cm (83.3.245).

During the Renaissance, European craftsmen made small panels composed of thin, flat glass panes that were painted and stained. Especially popular were panels decorated with family crests and images copied from engravings. Most of these objects were built into leaded windows, or suspended from chains or cords in front of them. This panel depicts two coats of arms, one belonging to the Escher vom Glas family of Zurich. The prunted glass beaker in the armorial design refers to the family business, the production and trade of plant ashes used in glassmaking. The panel was probably crafted in the workshop of Lukas Zeiner, one of the most talented glass painters working in Switzerland in the 16th century.

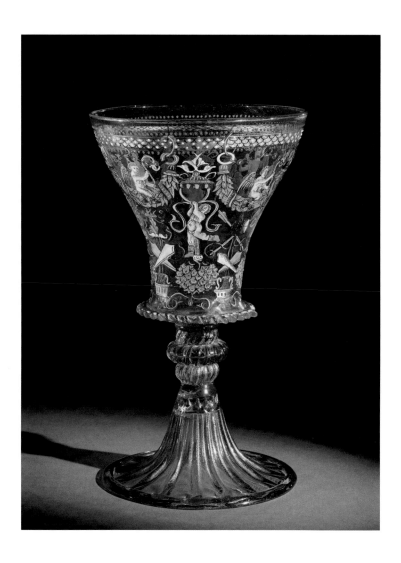

Enameled goblet

Italy, Venice, about
1500–1525. H. 23.6
cm (53.3.38).

After the 13th century, fine Venetian glass was decorated with gilding and fired enamels. Decorating a *cristallo* goblet with enamel was an elaborate process executed by specialists. Finely powdered glass, colored with metallic oxide and suspended in an oily medium, was applied to a vessel with a brush. As the glass was fired in the furnace, the medium burned away. Sometimes, several firings were required to fuse the various colors of an ornately enameled object. During the Renaissance, decorative motifs derived from classical antiquity were inspired by the discovery of ancient Roman wall paintings. These motifs, interlaced with vines or ribbons, included fantastic creatures, flowers, and coats of arms. The glass decorator probably used contemporary engravings as a source for these designs.

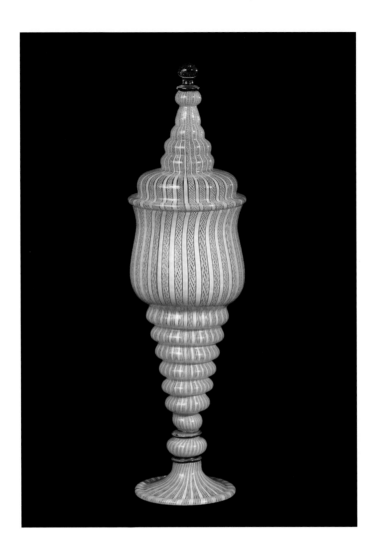

Covered goblet with filigree decoration

Italy, Venice, or northern Europe, 16th or 17th century. OH. 34.9 cm (64.3.9).

Filigree decoration originated at Murano in the 16th century and quickly spread to other parts of Europe. In this covered goblet, twisted canes of white glass encased in colorless glass alternate with plain white canes. These canes were arranged in a rectangular form and fused in the furnace to create a sheet of striped glass. The sheet was picked up on a disk of molten glass attached to the blowpipe, rolled up into a cylinder, and closed at the end to form an elongated bubble. This bubble was then divided into separate sections, from which the foot, knop (a small knob in the stem of a glass vessel), bowl, and matching lid were fashioned. A team of skilled craftsmen collaborated on such vessels, which were made in a great variety of twisted cane and network patterns. Filigree glass remained popular for more than 200 years.

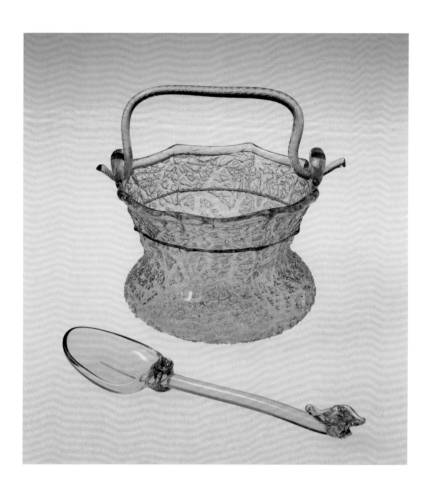

Ice glass bucket and spoon

Italy, Venice, 17th century. H. (bucket, from handle) 11.4 cm (2000.3.5, 4).

Places of worship in private homes were often equipped with wall-mounted fonts, as well as small glass buckets, for holy water. The buckets were sometimes suspended from a metal hook on the wall of a bedroom or study. This bucket was made of glass with a surface that resembles cracked ice. There are two ways to achieve this effect. The first method calls for a parison of hot glass to be plunged into cold water and withdrawn quickly. The thermal shock creates fissures in the surface, and these impart a frosted appearance after the parison has been reheated to allow the forming process to continue. In the second method, chips of colorless glass, picked up on a gather (a gob of molten glass) as it is rolled across a flat surface, fuse to the bubble as it is reheated. Ice glass was first made in 16th-century Venice, where it was often blown into a mold and decorated with colored trails.

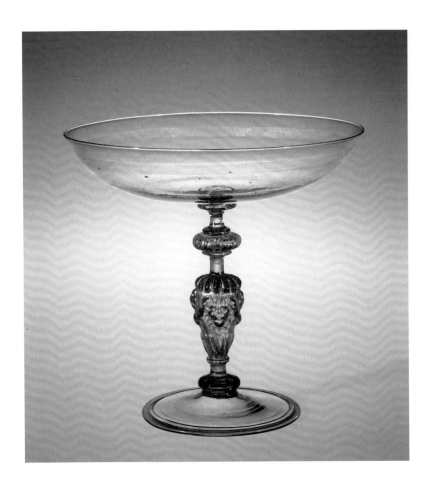

Lion-stemmed tazza

Italy, Venice, 16th century. H. 16.7 cm (58.3.180).

An Englishman traveling in Italy in the 17th century observed that "for the Italians that love to drink leisurely, they have glasses that are almost as large and flat as silver plates, and almost as uneasie to drink out of. . . ." The tazza, a most sophisticated glass for the drinking of red wine, allows maximum contact between the wine and oxygen in the air. Such glasses, which required a steady hand, are often seen in Italian pictures of the 16th and early 17th centuries. The lion-mask stem of this glass was blown in a two-part mold. It shows two lions' heads in full face, separated by shields. Composite stems were a staple in the repertory of 16th-century Venetian glassmakers.

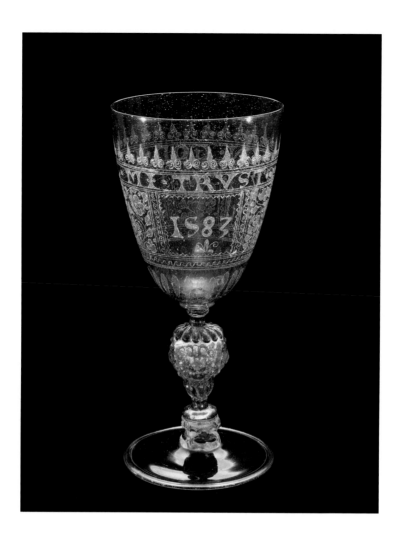

Goblet

England, London,
Crutched Friars
Glasshouse of
Giacomo Verzelini,
possibly engraved
by Anthony de Lysle,
dated 1583. H. 21.0
cm (63.2.8).

Venetian glassmakers were hired in England during the
16th century. One of them was Giacomo Verzelini. In 1571,
he was brought to London by Jean Carré, a French native and
owner of the Crutched Friars Glasshouse. Carré died the fol-
lowing year, and in 1575, Verzelini was placed in charge of
the glasshouse. The Crown gave him a 21-year monopoly on
the making of Venetian glass in England. His interests were
further protected by an embargo on the importation of glass
from Venice. Many of the objects made at Verzelini's glass-
house were diamond-point engraved by Anthony de Lysle,
who had immigrated from France. The inscription on this
glass, the only one with a lion-mask stem that is attributed
to the Crutched Friars factory, reads "IN.GOD.IS.AL.MI.TRVST."
It is the motto of the Pewterer's Company of London.

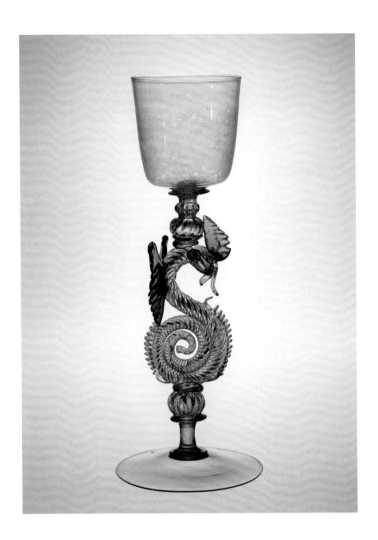

Dragon-stem goblet

Italy, Venice, or in the Venetian style, 17th century. H. 26.2 cm (51.3.118).

This dragon-stem goblet exemplifies the virtuosity of Venetian glassmakers. The complex, colorful stem shows a serpent with a convoluted body, outspread wings, open jaws, and a crest. Known in Italian as *vetri a serpenti*, serpent-stem goblets were very fashionable in the 17th century. The serpent motif is frequently found in the decorative arts of the Baroque period. The high viscosity of the Venetian soda-lime glass was ideal for the creation of such elaborate forms. Substantial numbers of large covered glasses with flat, symmetrical serpent stems were made by Venetian craftsmen in the Netherlands and Germany during the second half of the 17th century. In the 18th century, many of these glasses were engraved with genre scenes, floral motifs, and inscriptions.

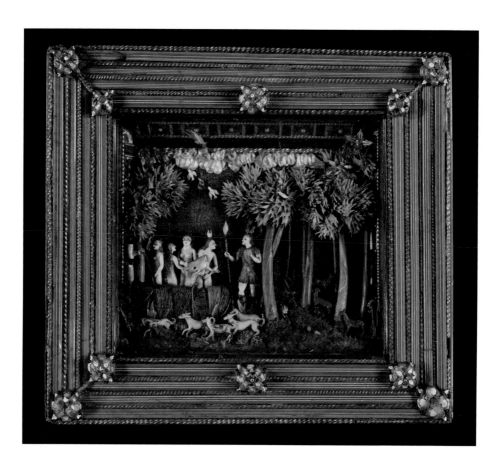

Diorama with Diana and Actaeon

Probably Austria, Hall in Tyrol, early 17th century. H. 21.9 cm (99.3.4).

This unique diorama portraying the myth of Diana and Actaeon was probably made by a Venetian lampworker at a court workshop in Austria in the early 17th century. The scene shows the hunter Actaeon, who chances on the goddess Diana and her nymphs bathing in a spring. Unable to cover her nudity in time, Diana angrily splashes water at Actaeon —water carrying a spell that turns him into a stag. On the glass picture, the hunter already has antlers protruding from his head. The group of dogs in the foreground alludes to Actaeon's imminent tragic death: not recognizing their transformed master, the dogs will give chase and tear him apart. This diorama was probably made for an educated and wealthy patron who delighted in curiosities.

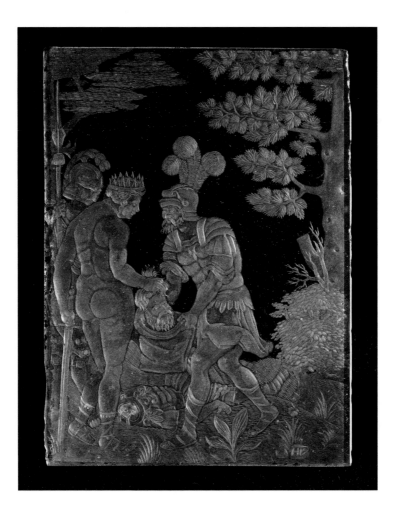

Plaque

Germany, Nuremberg, engraved by Hans Wessler, about 1610–1620. H. 15.5 cm (76.3.29).

This is one of the earliest known engraved glasses from Nuremberg. It is also the only known piece signed by Hans Wessler, a goldsmith and the first of that city's glass engravers. The plaque depicts Queen Thomyris with the severed head of Cyrus the Great, king of Persia in the sixth century B.C. Her story is related by the Greek historian Herodotus. Cyrus attempted to conquer the Massagetae in Central Asia, who were ruled by Thomyris. Although her son's forces fell victim to a trap set by Cyrus, her troops ultimately routed the Persians and killed Cyrus. In Western art, the revenge of Thomyris represents the victory of good over evil. The plaque shown here was based on a copper engraving of 1530 made by Georg Pencz (about 1500–1550) in Nuremberg.

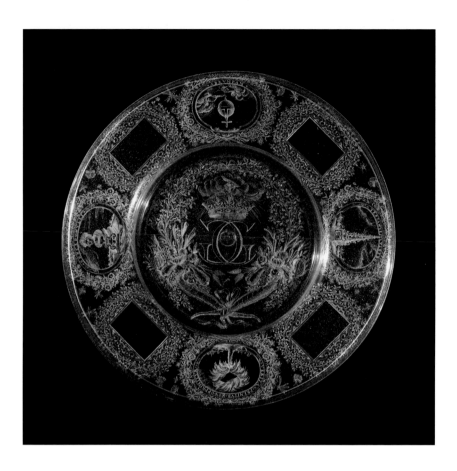

Diamond-point engraved dish

France or Low Countries, about 1640. D. 48.8 cm (77.3.34). Museum Endowment Fund.

The technique of decorating glass by scratching the surface with a diamond was introduced by the Venetians in the 16th century, and it was perfected in the Low Countries a century later. Unlike wheel engraving, which required a long period of training, the principal requirement of diamond-point engraving was the ability to draw well. This was certainly true in the case of the artist who produced the dish that is presented here. Its assurance of line proclaims it as one of the great masterpieces in its genre. The rim is decorated with emblematic designs, while the center shows the all-seeing eye of God above a crowned monogram composed of two Gs. The plate may have been made for Gaston, duke of Orléans (1608–1660), son of Henry IV of France.

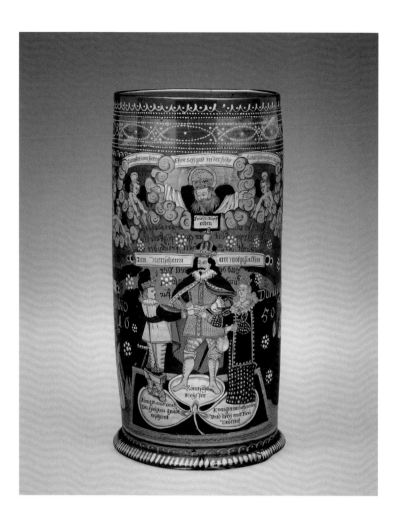

Westphalian Treaty *Humpen*

Franconia, dated 1650. H. 26.4 cm (57.3.54). Gift of Edwin J. Beinecke.

Humpen were large cylindrical glasses that held several quarts of beer. They were also some of the most popular enameled drinking vessels. Martin Luther, commenting on the custom of draining *Humpen* in a single gulp, called them "fools' glasses" and "obscenely large welcome cups." Most of these glasses were made in Bohemia, Germany, and Austria from the mid-16th to 18th centuries. The decoration on this fine *Humpen* commemorated the Peace of Westphalia (1649). The treaty ended the Thirty Years' War (1618–1648), which established France as the most powerful nation on the Continent. The scene shows the Holy Roman Emperor joining the hands of the king of France and the queen of Sweden, surrounded by kneeling ecclesiastics and laymen, beneath a heavenly assembly. The vessel also features inscribed biblical quotations and a prayer of thanks.

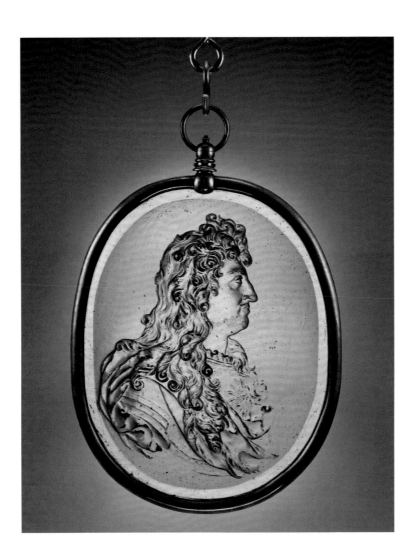

Medallion with portrait of Louis XIV

France, probably Orléans, Bernard Perrot, about 1675–1685. H. (frame) 38.7 cm (99.3.2).

This is one of the largest French glass objects known from the 17th century. It celebrates the Sun King, Louis XIV, and it was created during his lifetime. The glass portrait is attributed to Bernard Perrot (1619–1709), the best-known French glassmaker of that period. He emigrated from Italy to Orléans, France, where he founded a glasshouse with the support of the duke of Orléans in 1668. Perrot made several significant technical discoveries. One of his most important contributions was a secret method of casting glass to produce relief figures and medals. This heavy medallion was cast in a mold of the royal effigy that was based on gold medals of the monarch dating to the 1670s. Seven medallions of Louis XIV, originating from three different molds, are known today. All of the other examples are in French collections.

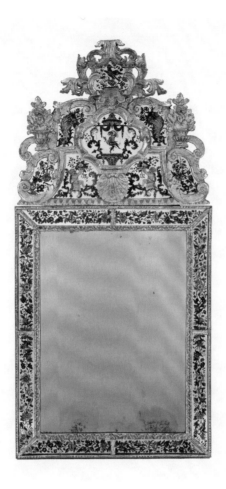

Reverse-painted mirror

Sweden, Stockholm, probably workshop of Christian and Gustaf Precht, 1720–1730. H. 145.0 cm (98.3.18).

During the Northern Baroque period, craftsmen produced mirrors as integral parts of elegant interiors. This example is attributed to the Stockholm workshop of Christian and Gustaf Precht, sons of the well-known woodcarver and furniture maker Burchardt Precht the Elder. It is decorated with ornate and very accomplished reverse painting. In this technique, a design is painted on the back side of the glass but viewed from the front (that is, through the glass). The paint is applied in the reverse of the normal order, beginning with the highlights and ending with the background. The Corning mirror shows a jester dancing under a canopy. This motif was inspired by the published designs of Jean Berain the Elder (1640–1711), royal designer to King Louis XIV of France. In the early 18th century, jesters and mirrors often appeared in allegories of vanity, symbolizing human folly and haughtiness. Mirrors of this type with figural decoration are exceedingly rare.

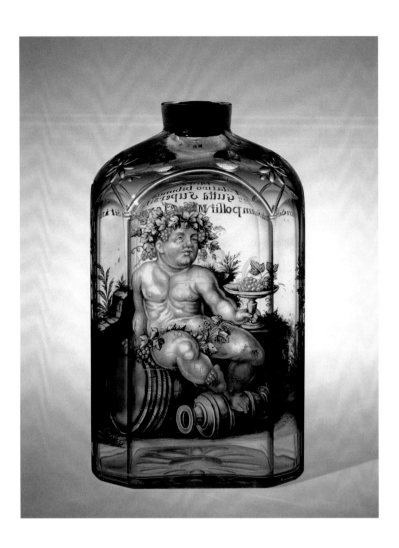

Heraldic flask

Bohemia, probably Kronstadt, enameled by Ignaz Preissler, 1720–1730. H. 20.9 cm (78.3.3).

The use of transparent enamels to decorate glass vessels was an important German innovation. This flask, which bears the arms of the Leon family of Anhalt in Saxony, probably belonged to a set contained in a traveling case. It was enameled by Ignaz Preissler (1676–1741), who worked as a painter of porcelain and glass in Kronstadt, Bohemia. He used a variety of sources for his painting. The image of the young Bacchus shown on this flask is derived from a woodprint by Jost Amman (1539–1591) that was contained in a book of illustrations published in Frankfurt in 1578. That book was widely used as a design source by decorators of glass and ceramics. The flask is painted in black and red, with added touches of purple. The inscription is translated, "We drink in the Palatine way so that not a drop is left from which a fly could quench its thirst."

Later European Glass

In the 17th century, changes in taste and technology transformed the glass industry in northern Europe. Glassmakers found new ways to make perfectly colorless glass. Two technological breakthroughs in the last quarter of the century resulted in glass that was more brilliant than ever before. The English achieved this effect by adding lead to the batch (the molten mixture of raw materials), while the Bohemians added chalk.

Glass containing lead had been made in Europe before the 17th century, but a lead-potash formula that was clearer and stronger than common soda-lime glass was not developed until the mid-1600s. By adding a high percentage of lead oxide to the batch, a relatively soft glass that could be covered with polished wheel-cut facets was created. Lead glass dominated the market in northwestern Europe, the Far East, and the American colonies.

Bohemian glassmakers added large quantities of chalk (carbonate of lime) to the batch to provide stability. Their new, hard glass was well suited to cutting or wheel engraving. Court engravers decorated large, thick-walled vessels with ornate designs.

English and Bohemian glassmakers also improved the opaque white glass that imitated porcelain. Another glassmaking innovation occurred in Potsdam, where the chemist Johann Kunckel produced a deep red or ruby glass by adding gold chloride to the batch.

With the growth of industrialization and the middle class, there was an increasing demand for elegant consumer goods. Glassmakers responded with a wide assortment of high-quality products. The skill of the glass decorators—cutters, engravers, and painters—became as important as that of the glassblowers. Their largest and most elaborate works were regularly displayed at world's fairs. The first of these fairs, the 1851 Great Exhibition in London's Crystal Palace, attracted more than six million visitors.

An artistic revival that occurred in Europe during the second half of the 19th century drew upon historic techniques, styles, and decorative motifs. The German term *Historismus* describes this phenomenon. Glass designers were also inspired by nature, symbolism, and Oriental art.

Goblet

England, London,
Savoy glasshouse of
George Ravenscroft
(marked), 1676–
1678. H. 18.8 cm
(50.2.2).

In March 1674, the English glassmaker George Ravenscroft applied for a patent to make colorless lead glass. Unfortunately, this glass was prone to crizzling, a chemical instability that results in an attack by atmospheric moisture, producing a network of cracks in the surface. Ravenscroft revised his formula, adding more and more lead oxide to the batch. By mid-1676, he announced that his improved glasses were to be marked with a seal—a custom known from several glasshouses that made lead glass. His stamp featured a raven's head, taken from his family's coat of arms. Corning's rare Ravenscroft goblet was made with the new lead formula. It is decorated with mold-blown ribbing that is pinched to form a mesh design on the bowl. This pattern is called "nipt-diamond-waies." One of the prunts at the bottom of the stem is stamped with a raven's head.

Covered beaker

Brandenburg, Potsdam, probably engraved by Gottfried Spiller, about 1700. OH. 21.9 cm (58.3.185). Gift of Edwin J. Beinecke.

Shortly after the English perfected lead glass in the 17th century, Bohemian glassmakers also developed colorless glass. In 1689, Louis Le Vasseur d'Ossimont, who worked near Winterberg, invented a potash-lime glass using chalk as a major batch material. Other European glasshouses were soon using this formula. The thick-walled glass was ideal for cutting and engraving. Intricate designs were created by pressing the glass against copper or stone wheels that were turning rapidly. This covered beaker was cut in relief, as well as engraved in intaglio so that the decoration lay below the surface plane. It was made for Elector Friedrich Wilhelm III of Brandenburg, and it was probably engraved by Gottfried Spiller, who co-founded an engraving workshop in Potsdam with his teacher, Martin Winter. Following Winter's death in 1702, Spiller became the royal glass engraver.

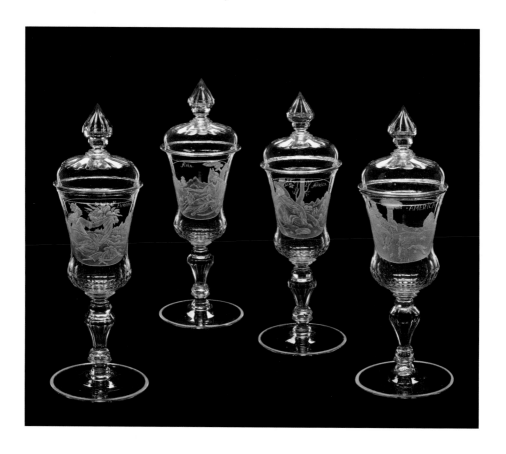

Continent goblets

Saxony, probably Glücksburg glasshouse, about 1710–1725. OH. 44.0 cm (99.3.37).

This unusually large set of four covered goblets was probably made in Glücksburg, Saxony. Each is cut and engraved on one side with a female personification of one of the four continents that were known in the early 18th century. "Africa" is taken from a design by the Flemish painter Dirk Barentsz (1534–1592). "America" was represented as part of the tropics, sharing with Africa the connotation of a "savage" country. "Asia" was the real source of wealth for Europeans. Richly dressed, she reclines in a luscious landscape that recalls Persian gardens dotted with domed buildings. "Europa" appears with the traditional attributes of power: the crown and the orb. Thus endowed, she remains the queen of the four parts of the world. The master engraver who worked on this set apparently did not complete his ambitious task. The panel depicting America was engraved by a less-accomplished hand.

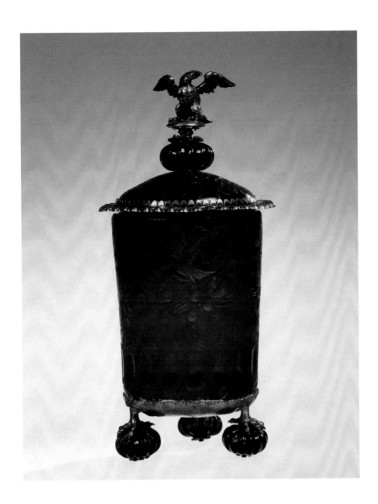

Covered beaker on ball feet

Southern Germany, mounted in Augsburg, about 1700. OH. 23.4 cm (79.3.308). Gift of The Ruth Bryan Strauss Memorial Foundation.

Johann Kunckel (about 1632–1703) invented gold ruby glass between 1678 and 1685. Friedrich Wilhelm III, elector of Brandenburg, supported this German scholar and chemist in his attempts to develop new varieties of luxury glass at the glasshouse in Potsdam-Drewitz, near Berlin. There, Kunckel made gold ruby glasses using a complex process that required a separate furnace and expensive raw materials. As a reward for his success, the elector gave him Peacock Island on the river Havel, where Kunckel built his own glassworks in 1685. This factory was destroyed by fire three years later, and Kunckel's glassmaking career never revived. Although gold ruby glass was always a luxury, it was soon being made by other glasshouses. One of them was located in southern Germany, possibly around Nuremberg, but its exact location has not been identified. The deep color of gold ruby glasses provided a fine background for bold cutting and restrained engraving.

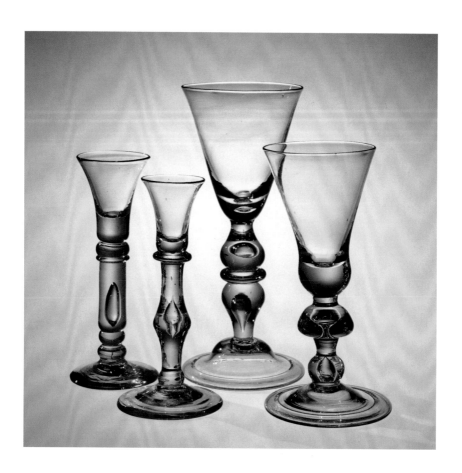

Group of baluster goblets

England, 1700–1740. H. (tallest) 21.7 cm (79.2.86, 65, 122, 77). Gift of The Ruth Bryan Strauss Memorial Foundation; bequest of Jerome Strauss (79.2.122).

The baluster was a type of English drinking glass made in the late 17th and early 18th centuries. Its stem was in the form of a baluster, a short vertical support with a circular section and a vaselike outline. This motif, adopted from Renaissance architecture, had been employed on early 17th-century Venetian glasses. Balusters were first made in England shortly after George Ravenscroft introduced his lead glass, and they became very popular. The stems of these heavy glasses contained knops and air traps that reflected and refracted light. Inverted baluster stems, which resembled the Venetian glasses, were made until 1710. For the next 25 years, true baluster stems were in demand. Knops, which were arranged in various ways, were found on a wide range of objects, including candlesticks as well as drinking and dessert glasses.

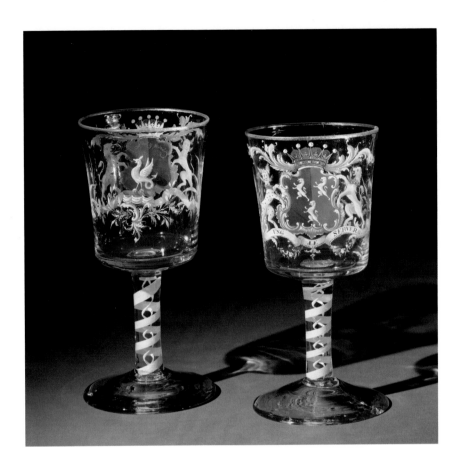

Pair of armorial goblets

England, Newcastle upon Tyne, designed by William and/or Mary Beilby, signed "Beilby," about 1760–1770. H. 22.7 cm (50.2.8).

The enameling of transparent colorless glass was popular on the Continent after the mid-16th century, but it would be another two centuries before the practice was adopted in England. This innovation was probably due to the Beilby family of craftsmen, which was located in Newcastle upon Tyne. William Beilby and his younger sister Mary enameled glasses in the ornate Rococo style from about 1762 until 1774. Early pieces, probably by William, were influenced by the heraldic engravings of his brother, Ralph. They include eight goblets bearing the royal arms of George III. The Beilbys' later works were decorated with rustic scenes, gardens, and classical ruins. Some of these objects are signed with the surname only, so it is not possible to know which Beilby enameled them. These two signed goblets show the arms, crest, and motto of the earls of Pembroke and Montgomery. They were made for Henry, 10th earl of Pembroke (1733–1794).

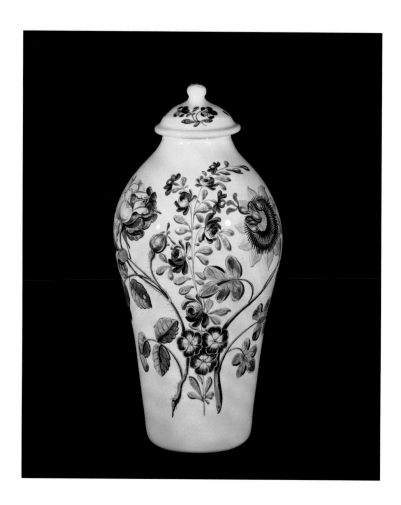

Covered vase

England, probably South Staffordshire, perhaps decorated in London, 1760–1765. OH. 25.3 cm (82.2.3).

During the 17th century, Britain's East India Companies brought more and more tea, spices, porcelain, and lacquer to Europe. Artists and craftsmen there began to make objects that invoked the exotic spirit of the East without merely imitating the Asian imports. Some of them were made of slightly translucent white glass that resembled expensive Chinese porcelain. Independent decorators often painted and gilded both glass and porcelain. The Europeans' chinoiserie style of decoration featured gilding, asymmetrical forms, unusual perspectives, and Oriental motifs. This covered vase was part of a garniture, a group of flower vases and covered urns that often graced the mantel of a fashionable drawing room. It is decorated with a large formal bouquet of brilliantly enameled flowers.

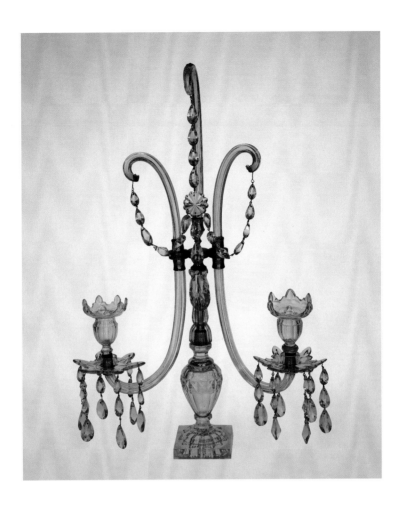

Candelabrum

England, Moses Lafount (signed), about 1800. H. 61.9 cm (51.2.226).

By the late 18th century, English manufacturers had taken full advantage of the refractive qualities of lead glass by adding sophisticated cutting to their wares. In 1780, Parliament lifted a 35-year ban on the exportation of Irish glass, and the tax-free Irish glass industry responded by producing large quantities of wares for export. Many English glassworkers moved to Ireland to take advantage of the financial benefits. The styles of English and Irish cut glass became very similar, and this glass is often referred to as "Anglo-Irish." Luxurious consumer goods, offered in fashionable London showrooms, included many light fittings. Wax candles were an expensive commodity, and efforts were made to maximize the amount of illumination they could provide. Moses Lafount, a "lustre-mounter" in London, patented this design for a candelabrum constructed with ormolu mounts. Festoons of cut drops added a magnificent jewel-like appearance to the elegant neo-classical shape.

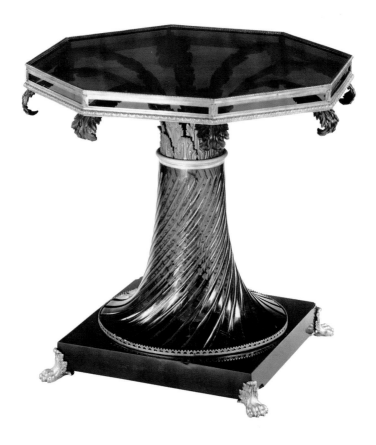

Table

Russia, St. Petersburg, Imperial Glassworks, about 1808. H. 79.0 cm (74.3.129). Purchased with the assistance of the Museum Endowment Fund.

Glass-encrusted furniture was popular during the last half of the 18th century. In the 19th century, some furniture was made almost entirely of large pieces of glass. The Imperial Glassworks in St. Petersburg, Russia, created tables, stands, urns, and chandeliers for palaces. This cut glass table, designed by Thomas de Tomon, was made at the Imperial factory about 1808. It was probably a present from Czar Alexander I to his mother or sister. The table consists of a single slab of blue glass cut in the shape of an octagon, resting on a single piece of amber-colored glass decorated with spiral cutting. The square base of amber glass is so dark that it appears black. These components are held together and embellished by elements of gilded bronze. A ewer and a basin of blue and colorless glass, wheel-cut with diamonds and mounted in ormolu, were made to accompany the table originally.

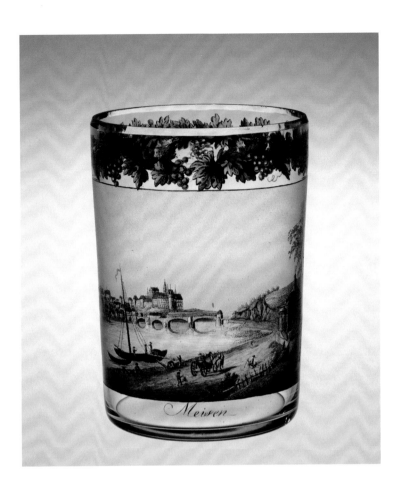

Beaker with a view of Meissen

Austria, Vienna, enameled by Gottlob Samuel Mohn, about 1810–1815. H. 10.3 cm (51.3.198).

Napoleon's defeat in 1815 brought peace and prosperity to Austria and Germany. A large middle class enjoyed a comfortable way of life. The style of restrained elegance and simplicity found in homes of this period was later termed "Biedermeier." Glasses made at that time were marked by classical taste. They were decorated with portraits, hunting scenes, and picturesque views of cities and towns. In the early 1800s, Samuel Mohn, a porcelain decorator in Dresden, was a leading figure in reviving the technique of painting in transparent enamels on glass vessels. His son, Gottlob Samuel Mohn, enameled beakers that showed scenes in and around Dresden. The example shown here is inscribed "Meissen." Mohn's glasses were often encircled by a colored floral garland below the rim. The vine border on the Corning beaker is an unusual variant.

Covered box of Lithyalin glass

Northern Bohemia, probably Friedrich Egermann, about 1830–1840. OH. 9.2 cm (60.3.58).

Two types of opaque glass were developed in the 1800s. In 1816, Georg Franz August Longueval (1781–1851), count of Buquoy, invented a dense, opaque black and red glass at the glasshouse on his estate in southern Bohemia. This glass, which he patented as Hyalith, was often decorated with gilding. The chemist Friedrich Egermann (1777–1864), who worked in northern Bohemia, created opaque glasses in a new range of rich colors. He developed a polished, marbled glass that looked like semiprecious stone. In 1828, he patented this as Lithyalin (from Greek *lithos*, "stone"). He continued to produce this glass in many decorative styles until about 1840.

**Carafe
and stopper**

England, London,
Falcon Glassworks
of Pellatt & Co.
(signed "Pellatt"),
about 1862. H. 30.4
cm (97.2.8).

One of the most prolific and innovative 19th-century English glasshouses was operated by Apsley Pellatt. In 1820, he patented his "crystallo-ceramie" process, which improved on the French method of making sulphides (small ornamental objects of white porcelainlike material, made to be encased in glass). Later, he published *Curiosities of Glassmaking*, which supplied information about glass manufacturing and decorating techniques. Pellatt's Falcon Glassworks in London produced quality lead glass tableware and lighting devices. Some of this company's best works were displayed in London at the world's fairs of 1851 and 1862. An exquisitely engraved lead glass carafe, which is signed "Pellatt" under a crown at the base of the handle, was shown at the 1862 exposition. The body of the vessel is decorated with three cartouches enclosing arabesques. The cartouche beneath the spout depicts a stylized round table with five Venetian Renaissance glasses.

Table and cut glass boat

France, Baccarat, Compagnie des Verreries et Cristalleries de Baccarat, 1878 (table) and 1900 (boat). OH. 167.0 cm (79.3.155).

Glass furniture became more popular and complex in the late 1800s. Factories competed to produce elaborate objects for display at world's fairs. The table shown here was probably part of a spectacular exhibition of glass furniture at the Paris exposition of 1878. Baccarat's display at that exposition was shown in a gallery called the Salon of the Thousand and One Nights. The products of this French company set the tone for design and execution of European glass for decades to come. The table was one of four made by the company. The cut glass boat was designed for Baccarat by the sculptor Charles Vital Cornu. It was displayed with the table for the first time at the 1900 world's fair in Paris.

Cameo plaque,
Moorish Bathers

England, Amblecote,
Thomas Webb &
Sons, George Wood-
all (signed), 1898.
D. 46.3 cm (92.2.10).
Bequest of Mrs.
Leonard S. Rakow.

In the late 1800s, cameo glass became extremely fashionable. To meet the demand, the English firm of Thomas Webb & Sons expanded to include about 70 engravers. Their output was prodigious. The greatest of all the English cameo glass carvers was George Woodall. The work illustrated here, *Moorish Bathers*, is his largest and most ambitious plaque. It portrays seven female figures—the largest number of figures on a Woodall piece—in a Moorish setting. The plaque was begun about 1890 and completed in 1898. Minute details are rendered with astonishing delicacy. On the head of the central figure, for example, tiny eyelashes project in front of the bridge of the nose. In a 1912 interview, Woodall described *Moorish Bathers* as his masterpiece.

**Micromosaic
with a view
of the Basilica
of San Marco**

Italy, Venice, E.
Cerato (signed),
dated 1907. W.
(frame) 203.2 cm
(96.3.36). Gift of
Dorothy and
Charles J. Plohn Jr.

This may be the largest Venetian micromosaic in existence. It measures five by seven feet, and it weighs one ton. As a rule, micromosaics are small works that emphasize detail; rarely do they exceed the size of a modest painting. This panel depicts Venice's Piazza San Marco and its basilica. It provides an almost photographic record of the mosaic decoration on the basilica's facade as it existed at the start of the 20th century. The panel is signed by the mosaicist E. Cerato, and it was on display in the store of the glass company Pauly & C. at the Piazza San Marco until the late 1950s. Developed in Italy during the late 18th and early 19th centuries, the micromosaic technique made use of minute tesserae of colored glass that were arranged to create painterly effects. These tesserae were cut from thin opaque glass rods, of which there were more than 20,000 different tints.

Asian Glass

In the Far East, glass was not valued as highly as it was in the West. The Chinese and Japanese were not interested in the fluid, moldable, and transparent qualities of glass. They thought of glass as artificial stone, and they preferred such natural substances as jade, coral, rock crystal, and precious gemstones.

Glass beads and other small artifacts dating from at least as early as the Warring States Period (475–221 B.C.) have been found in Chinese graves. China imported Roman, Sasanian, and Islamic glass, and glasses were shown in early Chinese paintings. According to legend, the secrets of glassblowing were brought to China by Western travelers in A.D. 435. But relatively little is known about Chinese glassmaking until the beginning of the Qing dynasty (1644–1911).

In 1680, Emperor K'ang Hsi established the Imperial Palace Workshops in Peking (Beijing) under the supervision of Jesuit missionaries. Some of the glass made there imitated porcelain. Carved cameo glass, an important part of China's glassmaking, developed independently from European cameo glass. In the mid-1700s, the imperial glassworks was moved from Peking south to Poshan (Boshan). However, master craftsmen at the court in Peking continued to cut the blanks for cameo glass.

Glass in early Japan was used for sacred objects, such as relic jars and offerings at shrines. Most of this glass came from China. *Ruri*, a blue glass that looked like lapis lazuli, was especially popular in Japan, where glassmaking grew from 1603 to 1868 under feudal authority. By 1650, Japanese glasshouses made a wide variety of wares. These ranged from small game pieces and spectacle lenses to large vases and the telescope lenses that were popular with the upper classes.

In India, the Mughal glass industry was at its peak during the 17th century. Glass objects, especially foreign ones, were highly regarded. Indian craftsmen decorated some imported glass by cutting, gilding, or painting with enamels. In the 19th century, blocks of English glass were sent to India for remelting and local manufacture of vessels. Today, India exports large quantities of glass tableware, bottles, bracelets, and beads. A few small factories continue to make glass bangles by traditional methods.

Carved ceremonial objects from early China, blown and cut vessels made in Japan, beaded containers from Indonesia, and a variety of luxury glassware from India exemplify glass production in Asia.

Ritual disk (*bi*)

China, Han dynasty
(206 B.C.–A.D. 220).
D. 16.4 cm
(51.6.548).

In ancient China, decorated ritual disks known as *bi* were made of jade and other materials. Archeologists have unearthed many glass *bi* in Hunan and other provinces. A document of the Warring States Period includes this reference: "to pay tribute to heaven with dark green *bi*." This indicates that *bi* were ceremonial objects, but archeologists have determined that they were used mainly as decorations to be buried with the dead. Earlier *bi* are small and thin, while later disks are large and thick. The size of a *bi* indicated the social status of a tomb's occupant. *Bi* and other excavated glass objects provide solid evidence of glassmaking in China from the fifth century B.C. onward.

Warrior Vase

China, probably
Qianlong period
(1736–1796). H.
49.2 cm (57.6.10).
Gift of Benjamin D.
Bernstein.

Ruby glass was often used to encase Chinese objects that
were subsequently cameo-carved. Although it is commonly
found on snuff bottles of the 18th and 19th centuries, it can
also be seen on such uncommonly large objects as the War-
rior Vase. This vase was wheel-cut through the ruby over-
lay to reveal an inner layer of "frosted" colorless glass. The
ruby layer was carefully worked to produce a three-dimen-
sional scene of considerable depth. The elaborate scene de-
picts warriors racing past a temple where priests are wor-
shiping.

Snuff bottles

China, late 18th–19th century. H. (tallest) 8.9 cm (82.6.19, 48, 40, 59, 16). Bequest of Marian Swayze Mayer.

The habit of taking snuff (inhaling powdered tobacco) spread to China from the West following the establishment of the Qing dynasty in 1644. While the smoking of tobacco was forbidden at that time, snuff was regarded as a remedy for a wide variety of diseases. Powdered tobacco and other Chinese medicines were dispensed in bottles rather than in boxes, as was customary in Europe. Snuff bottles were made of various materials, including hardstones, porcelain, ivory, and glass. The glass in many snuff bottles imitated semiprecious stones. Most of these bottles were oval with flattened sides, making them easy to carry. Small stoppers, often in contrasting colors, were attached to tiny spoons used for taking the snuff. The best bottles were carved, enameled, or painted on the inside with tiny landscapes, portraits, or inscriptions.

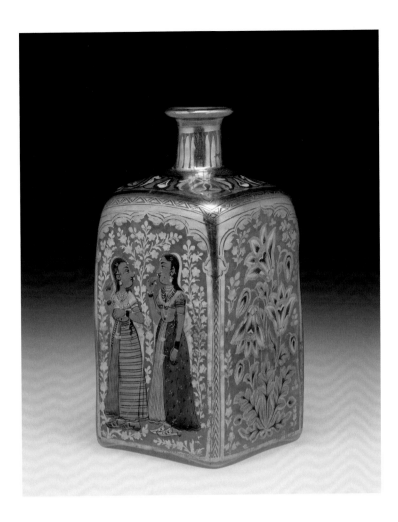

Bottle

Perhaps Europe, painted in India, second quarter of the 18th century. H. 13.0 cm (59.1.583).

The Mughal emperors were great patrons of art. They established royal workshops that produced a wealth of masterpieces. Paintings of the imperial court depict opulent settings, with ornate wine decanters, bottles, cups, salvers, and water pipes. Some glass bottles were imported from Europe, but others were manufactured in India. The Indian origin of this bottle is shown by the costumes of the maidens and the style of the floral decoration painted on the glass. Bottles of this type were probably made on the Kathiawar Peninsula of Gujarat during the early 18th century or slightly later. The colorful decoration was applied with gilding and polychrome enamel. The Corning bottle may have belonged to a set that was placed in a traveling case.

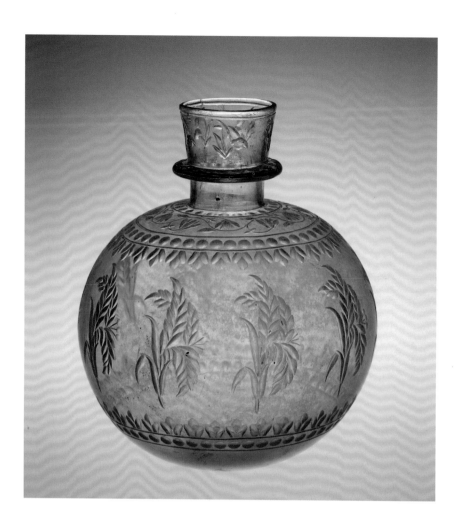

Base of a water pipe (hookah)

Probably made in England and decorated in India, mid-18th century. H. 17.5 cm (71.6.1).

Tobacco smoking appears to have arrived in India during the reign of the Mughal emperor Akbar (1556–1605). The hookah was a water pipe in which tobacco smoke was sucked through scented water to cool it and to eliminate its harsh quality. With the establishment of the East India Company, English exports of glass to the Indian subcontinent increased dramatically. These exported wares included hookah bases made of high-quality glass that probably contained lead. The hookah base shown here is thought to have been wheel-engraved in India, perhaps in Delhi, because it matches, both in style and in technique, the engraving on jade and rock crystal made for the Mughal court.

Sakazuki set

Japan, Shuseikan
Kyushu, Satsuma
Clan factory, about
1857. D. (largest)
11.0 cm (55.6.18).
Gift of the Asahi
Glass Company.

In mid-19th-century Japan, luxury glass produced in Satsuma province was a major source of revenue. The province's powerful leader, Nariakira Shimazu, encouraged the development and production of glass of high artistic quality. Red and dark blue were popular colors for luxury wares. On early examples, the cutting is "soft" and not highly polished. Later products, such as this *sakazuki* set, are sharply cut and highly polished. This set of three graduated and nested sake cups (with an accompanying glass stand) was cut from colorless glass covered with a dark blue overlay. It was reserved for ceremonial occasions, such as New Year celebrations and weddings. Sake, an alcoholic beverage made from fermented rice, is the drink of the gods of Shinto, the native religion of Japan.

Three beaded wedding baskets

Indonesia, Sumatra, Lampung Bay area, probably 1930–1960. H. (tallest) 26.4 cm (97.6.1–3).

Beaded objects for private ceremonial use were usually created by amateur beadmakers. One example is a set of three beaded wedding baskets from Indonesia. Baskets woven of natural fibers were covered with cotton cloth that was densely embroidered with European seed beads, bugle beads, and *hassa* shells. The decoration includes sunbursts, butterflies, and a tree of life. These are traditional Western and Sumatran images representing protection, guidance, supplication, and remembrance. The baskets are used mainly for the presentation of wedding gifts, usually food or cloth. They are carried to the celebration on the head—a mode of transportation facilitated by their indented bottoms. Today, these baskets have largely gone out of fashion. They are infrequently used even in the rural communities of the region.

Glass in America

Glassmaking was America's first industry. Colonists built a glass workshop at Jamestown, Virginia, in 1608. However, despite good sand and an abundance of fuel, several factors—including severe winters and the sheer distance to markets in England—combined to force the facility to close. Throughout the 17th and early 18th centuries, the colonists imported glass for windows and tableware.

Three German entrepreneurs—Caspar Wistar, Henry William Stiegel, and John Frederick Amelung—established successful glasshouses in the 1700s. By the end of the century, the Boston Crown Glass Manufactory was making window glass that was as good as its imported counterpart. But it was not until after the War of 1812 that American manufacturers were finally free of restrictive trade policies that hampered production.

Despite financial uncertainties and competition with English imports, glassmaking in America increased during every decade of the 19th century. While European glass factories continued to focus on lavish products for the tables of the rich, American manufacturers concentrated on bottles and window glass, confident that they could undersell their foreign competitors.

The hand-operated pressing machine, developed in the 1820s, was America's most important contribution to the glass industry. It tripled the production of tableware, which was now readily available to the general public at greatly reduced prices. A completely decorated bowl came out of the press in just a few seconds. Table glass was produced in sets like china, encouraging housewives to buy more.

In the mid-1800s, as American industry and prosperity steadily increased, a taste developed for ornate styles and complex decoration. Glass was made with such exotic names as Amberina, Burmese, and Peachblow. Cutting became more and more elaborate, and some pieces were so profusely cut that not a half-inch of surface was undecorated.

Michael Owens ushered in the era of modern mass production in 1903 by inventing a machine that manufactured bottles automatically. In the 1920s, machines pressed tableware that is now collected as "Depression glass," and a ribbon machine installed by Corning Glass Works produced 2,000 light bulbs per minute, nearly three million in a day.

This gallery displays the earliest glass made in the United States. It traces the development of mechanical pressing, America's most important contribution to glassmaking. There is also a model of a factory for blowing window glass.

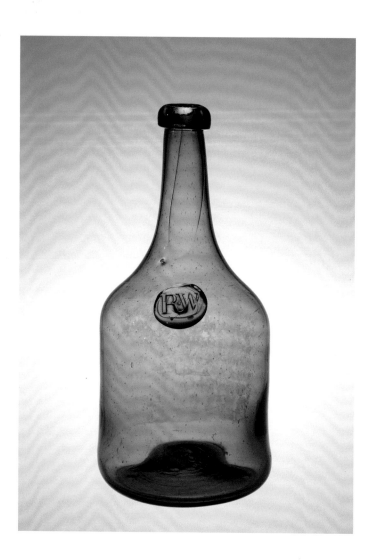

Bottle with the seal of Richard Wistar

U.S., Salem County, New Jersey, Wistarburgh Glassworks, about 1745–1755. H. 23.5 cm (86.4.196). Gift of Elizabeth Wistar.

The first successful glass factory in the Colonies was established by Caspar Wistar near Alloway, New Jersey, in 1739. Its principal products were window glass and bottles, which were in great demand. More than 15,000 bottles were produced there each year. Wistar's bottles were made using a typical *Waldglas* formula that had been popular in northern Europe since the Middle Ages. The impure greenish glass was fashioned into bottles so closely similar to the European variety that the makers of unmarked examples cannot be identified. This bottle bears the initials of Richard Wistar, eldest son of Caspar Wistar. It is one of only three marked bottles that can be attributed to the Wistar factory.

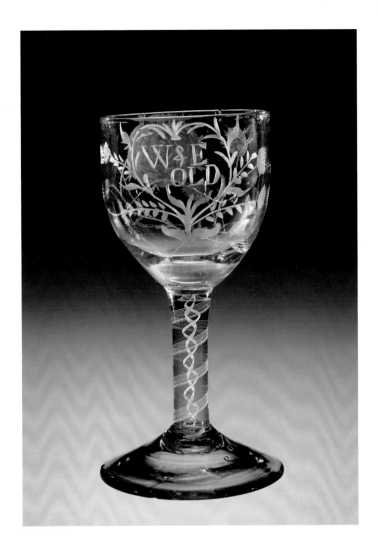

Wineglass

U.S., Manheim, Pennsylvania, American Flint Glass Manufactory of Henry William Stiegel, 1773. H. 17.2 cm (87.4.55). Gift in part of Roland C. and Sarah Katheryn Luther, Roland C. Luther III, Edwin C. Luther III, and Ann Luther Dexter.

Henry William Stiegel, who opened a glasshouse in Manheim, Pennsylvania, in 1764, was also a manufacturer of bottles. His main interest, however, was fine lead glass tableware in the English tradition. He advertised a wide assortment of table glass, including tumblers and decanters in several sizes. Unfortunately, none of the products from his factory, which closed in 1774, is signed. One of Stiegel's wineglasses was made to commemorate the marriage of his daughter, Elizabeth, to William Old. The couple's initials appear on the glass. This is the only known piece that can be positively attributed to the Stiegel glasshouse. It was acquired by the Museum from Stiegel's descendants.

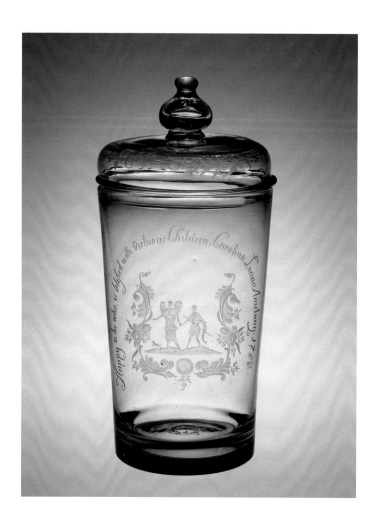

"Tobias and the Angel" tumbler

U.S., Frederick, Maryland, New Bremen Glassmanufactory of John Frederick Amelung, dated 1788. H. 21.4 cm (55.4.37).

One year after the American Revolution ended, John Frederick Amelung opened a large glasshouse in Maryland. Like Stiegel, Amelung remained in business for only 11 years, but in that time he invested more money in glassmaking than anyone in America before him. His factory turned out large quantities of table glass, much of which was engraved. Some of these pieces are signed and dated. One of them is this tumbler, which bears a scene from the Book of Tobit: an angel leads Tobias, the son of Tobit, on his journey to cure his father's blindness. The inscription, "Happy is he who is blessed with Virtuous Children," indicates that Amelung considered his life a happy one. Amelung made this goblet in 1788 for his wife, Carolina Lucia.

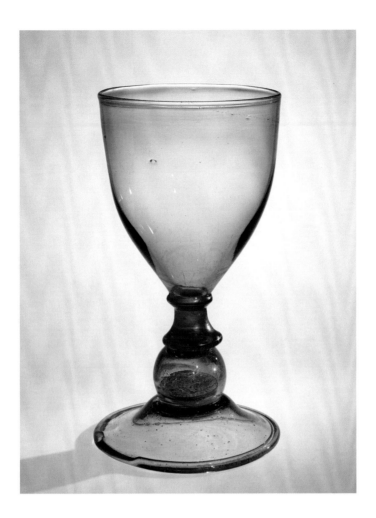

Goblet made for Albert Gallatin

U.S., New Geneva, Pennsylvania, New Geneva Glass Works, about 1798. H. 23.5 cm (79.4.329). Bequest of Jerome Strauss.

In 1797, the first glasshouse west of the Alleghenies was built in New Geneva, Pennsylvania. It was financed by Albert Gallatin, who had come to Pennsylvania from Geneva, Switzerland, in 1780. By the time his factory opened, Gallatin owned large properties in the western part of the state and was a member of the U.S. House of Representatives. He later served as Secretary of the Treasury under President Thomas Jefferson and as minister to France and to Great Britain. The large drinking glass shown here was made at Gallatin's glasshouse. It contains a silver "achievement" medal from the College of Geneva in Switzerland, from which Gallatin graduated in 1779. The goblet descended in the family of Charles Alexandre Mestrezat, one of Gallatin's relatives.

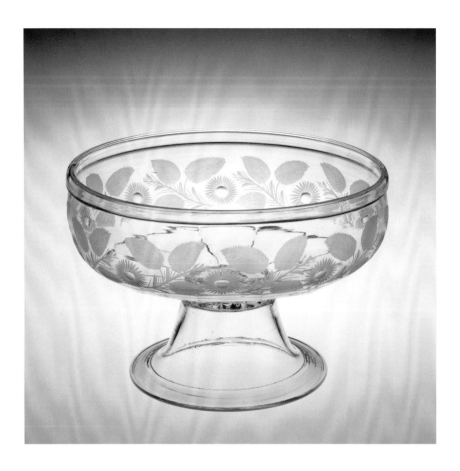

Footed bowl

U.S., Pittsburgh, Pennsylvania, Bakewell & Company, about 1815–1840. H. 16.2 cm (94.4.9).

As settlers moved west to the Alleghenies, they created a new market for glassware. But because glass was difficult to ship overland, many had to do without it in their windows and on their tables until the glass industry itself moved west. Pittsburgh was an ideal location for manufacturing because of its river transportation to the entire western frontier and because of its nearby coal deposits as a ready source of fuel. For many years, Benjamin Bakewell operated the largest glass factory in Pittsburgh. It was noted for its fine tableware. In 1817, when President Monroe wanted cut glass for the White House, he ordered it from Bakewell's. Although that factory is known to have made engraved glass in the early 19th century, relatively few such pieces can be attributed to it. One of them is this footed bowl.

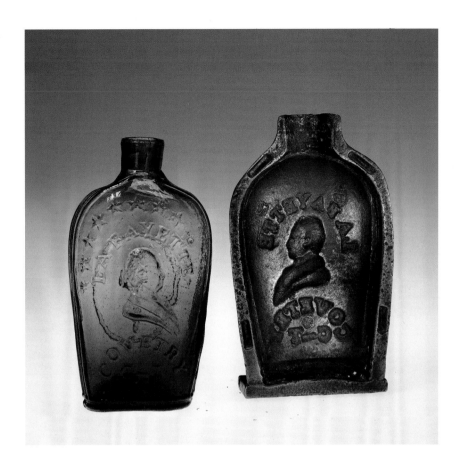

Half of brass mold and flask

U.S., Coventry, Connecticut, Stebbins and Stebbins, about 1824–1825. H. (flask) 18.5 cm (93.7.3, 60.4.87). Mold gift of Gladys W. Richards and Paul C. Richards.

The manufacture and decoration of hand-blown tableware was a slow and costly process. Glassmakers soon sought ways to speed production and to decorate their wares more cheaply. One way to do this was to blow the glass into a mold, which shaped the glass and decorated the surface in one operation. The earliest examples of this molded glass imitated cut glass. A housewife's book, published in 1815, suggested that "those who wish for Trifle dishes, butter stands, &c. at a lower charge than cut glass may buy them in moulds, of which there is a great variety that looks extremely well if not placed near the more beautiful article." The mold-blown flask shown here is decorated with a portrait of the Marquis de Lafayette, a French soldier and statesman who served in the American Revolutionary Army. Half of the brass mold in which this flask was made is also illustrated.

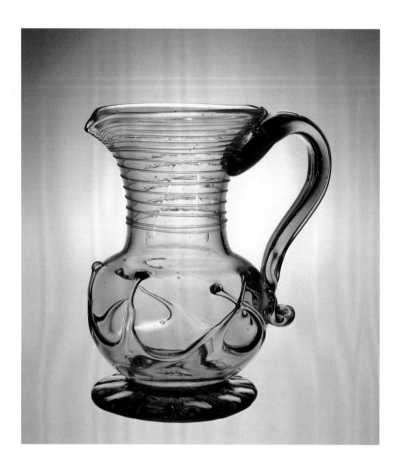

Pitcher

U.S., probably Lancaster or Lockport, New York, about 1840–1860. H. 18.5 cm (50.4.450).

The glass that was used to make this pitcher was also employed in the manufacture of windows because the brilliant deep aquamarine color would not have been noticeable in thinly blown sheets of window glass. The applied decoration on the pitcher resembles lily pads. This type of decoration, which is unknown on earlier European glasses, is considered to be an American innovation. Because glassmakers frequently moved, it is often impossible to determine precisely where such table wares were produced. The pitcher may have been made as a gift for the family or a close friend of the glassmaker. Until recently, glassworkers in America and Europe were permitted to use factory glass to fashion objects on their own time at no cost. These "end-of-day" creations are some of the most fanciful objects made in American glasshouses.

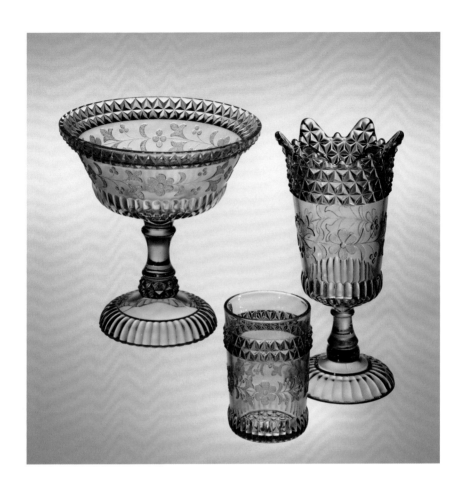

Footed bowl, celery vase, and tumbler in "Wild-flower" pattern

U.S., Pittsburgh, Pennsylvania, Adams & Company, about 1880–1891. H. (tallest) 22.1 cm (81.4.67, 69, 70). Gift of Mr. and Mrs. Crandall Melvin Jr. in memory of Gertrude Christman Melvin.

At a pressing machine, two men with minimal experience could produce four times as much glass as a team of three or four trained glassblowers. However, because contact with the cold mold produced an ugly network of wrinkles on the surface of some pieces, moldmakers turned from imitations of cut glass patterns to designs with stippled backgrounds. Where every inch of the piece was decorated, the wrinkles did not show. Technological improvements finally eliminated the wrinkles, and patterns became simpler in the 1840s. During that same decade, glass was made in matching table sets for the first time. Here are three pieces in the "Wild-flower" pattern, one of the earliest patterns to be pressed in a variety of colors.

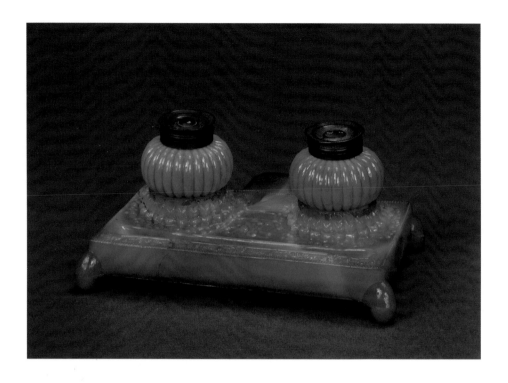

Desk set

U.S., Sandwich,
Massachusetts,
Boston & Sandwich
Glass Company,
about 1830. L. 18.5
cm (68.4.532).

The problems involved in pressing glass were summarized by a glassmaker in 1849: "If an overplus of metal [glass] be gathered, it thickens the article throughout; but if too little, it fails to fill up the mould, and is spoiled. . . . The chief condition of success, in getting a polished surface on pressed Glass, depends upon the moulds being kept . . . a little short of red heat." In this three-piece desk set, made about 1830, the color is not well mixed, and the surface has fissures from contact with the mold. Nevertheless, this object, which would have graced the desk of a fashionable home, is a very rare and attractive example of the glassmaker's craft. Only six such sets are known. This one contains two wells for ink and a slot for a pen.

Hairpin box

U.S., Jersey City, New Jersey, Jersey Glass Company, about 1834–1841. L. 12.3 cm (71.4.110).

As supplies of wood were depleted in the heavily populated East, glass factories there switched to coal. However, because coal often had to be shipped over great distances, it was considerably more expensive than the wood had been. Some glassmakers turned their attention from pressed glass to luxury wares, hoping to pass their higher manufacturing costs on to consumers. Many of these luxury wares were cut. This box for hairpins is cut with diamonds on the bottom and sides. The silver lid is inscribed "Mary Sarah Dummer." This object descended in the family of Phineas C. Dummer, proprietor of the Jersey Glass Company in Jersey City, New Jersey. This company won a silver medal for excellence in glass cutting at the American Institute Fair in New York City in 1843.

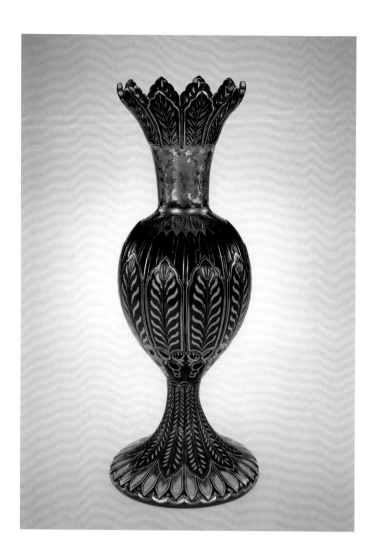

Vase

U.S., blown by
William Leighton at
the New England
Glass Company,
Cambridge, Mas-
sachusetts, 1848–
1858. H. 43.9 cm
(93.4.9).

Appearances can be deceiving. This cut and gilded vase
blown from four layers of glass—colorless, red, green, and
opaque white—is very Bohemian in appearance. However,
it was made by William Leighton at the New England Glass
Company between 1848 and about 1858. Leighton, son of
the factory's manager, was a very skillful blower and a self-
taught glass chemist. About 1848, he developed a formula
for ruby glass. Before that time, ruby glass was imported
from Europe in the form of ingots and remelted for use in the
United States. Because the vase is elaborately decorated, it was
probably made for display, possibly at the 1853 New York
world's fair, where the New England glassworks had an ex-
tensive display. The Corning Museum of Glass acquired the
vase from one of Leighton's descendants.

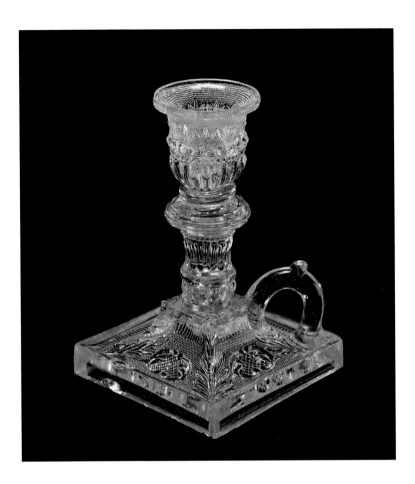

Chamberstick

U.S., New England,
probably Sandwich,
Massachusetts,
Boston & Sandwich
Glass Company,
about 1830–1840.
H. 13.9 cm (96.4.187).

Before 1800, most of the lamps and candlesticks used in America were made of metal. After that date, glass gradually became the most important medium for lighting devices. Although American pressed glass candlesticks are numerous, the base of this example is very rare. The socket is a relatively common pattern made at the Boston & Sandwich Glass Company, which also produced whale-oil lamps with mold-blown fonts and bases. Candlesticks with handles were usually called chambersticks because the handle made it easier to carry the candlestick into the bedchamber. The ring handle was difficult to press because the molten glass did not flow easily through the small space required. In addition, the ring is so small that it must have been difficult for an adult to carry the candlestick while it held a lighted candle.

Kerosene parlor lamp

U.S., Sandwich, Massachusetts, Boston & Sandwich Glass Company, about 1865–1875. OH. 109.7 cm (89.4.19). Gift of Kathryn K. Porter in memory of Helen McKearin.

In the mid-19th century, kerosene began to replace whale oil as a lamp fuel. Kerosene lamps required glass chimneys in order to burn properly, and this led to the birth of a new glass industry. More than 140 patents were granted for lamp chimneys and shades between 1855 and 1873. Even after the introduction of gas for home lighting, kerosene continued to be the major fuel until Edison's invention of the incandescent electric bulb in 1879. A single kerosene lamp was usually placed on a central table in the parlor, and the family gathered around it at night to read or study. The lamp illustrated here is one of the largest surviving examples of the parlor lamp. It is made of overlay glass, consisting of a colored outer layer that is cut to reveal the colorless inner layer. The Boston & Sandwich Glass Company was a large producer of this glass.

Electric lamp

U.S., possibly Philadelphia, Pennsylvania, Quaker City Glass Company, or Meriden, Connecticut, J. D. Bergen Company, about 1900–1915. H. 73.7 cm (96.4.157).

Another impressive lighting device in the Corning collection is a large electric lamp that was made in the early 20th century. Six lamps in this style are known, and all of them are cut with the same pattern. So far, the manufacturer has not been positively identified. One of these lamps was purchased in Chicago in the late 1930s or early 1940s, and another belonged to the pianist-entertainer Liberace, who seems to have acquired it in the 1950s. The other examples have been found in various locations around the country, so it does not seem likely that they are part of a set. The large size of these lamps suggests that they were used either in a spacious home or perhaps in the lobby of a hotel. In the home, only a very impressive parlor table could have accommodated such a lamp.

Morgan Vase of Peachblow glass

U.S., Wheeling, West Virginia, Hobbs, Brockunier & Company, about 1886–1891. OH. 25.5 cm (50.4.328).

Following London's Great Exhibition of 1851, the Victorian sense of "good taste" emphasized more ornate works. Some glassmakers met this demand by creating dramatic color effects. Several American factories produced Peachblow glass, which had a surface that shaded from opaque cream to pink or red, sometimes over opaque white. This glass was made in imitation of the Morgan Vase, a famous 18th-century Chinese "peachbloom" porcelain vase that sold at auction in 1886 for the astonishing price of $18,000. This sale was widely reported, and glass and pottery manufacturers raced to capitalize on the publicity by producing objects that resembled the Morgan Vase in shape and color. The pressed glass stand on the Morgan Vase in The Corning Museum of Glass was made to resemble the Chinese carved wood stand for the peachbloom vase.

Burmese lamp

U.S., New Bedford, Massachusetts, Mt. Washington Glass Company, about 1885–1895. OH. 48.5 cm (79.4.91). Gift in part of William E. Hammond.

Between 1870 and 1900, several types of glass with newly developed surface textures, shaded colors, and casing were made in America. One of these Art Glasses, which shaded from translucent pink to yellow, was called Burmese because its color was said to remind viewers of a sunset in Burma. In this Burmese lamp, the yellow and pink colors were produced by the use of uranium oxide and gold, respectively. Reheating the glass afforded the pink additional intensity. The firm that probably manufactured the largest amount of Art Glass was the Mt. Washington Glass Company of New Bedford, Massachusetts. It patented Burmese glass in 1885 and continued to make it until about 1895. Mt. Washington also marketed Royal Flemish, which resembled stained glass, and its Albertine, Crown Milano, and Dresden glasses were enameled to look like porcelain.

Light bulb tester

U.S., Coshocton, Ohio, American Art Works Inc. for the Edison Mazda lamp division of the General Electric Company, 1924–1934. OH. 69.5 cm (95.4.261).

Electric lighting was slow in coming to the American countryside. In the 1920s, lamps and bulbs were not the routine purchases they are today. Customers who wanted to test bulbs before purchasing them would use a bulb tester in their local hardware store. This nearly complete tester, with its period bulbs, is a rare find. It was made about 1925 by American Art Works Inc. in Coshocton, Ohio, for the Edison Mazda lamp division of the General Electric Company. The logo, which shows two knaves facing each other while they appear to be discussing or contemplating a light bulb, was designed by the American painter Maxfield Parrish. This logo first appeared—without the light bulb or the General Electric trademark—on the cover of the November 10, 1921, issue of *Life* magazine.

Crystal City

In 1902, the *New York Sunday Tribune* characterized Corning as the "Cut Glass City of New York State." At that time, about 1,000 men, women, and boys were blowing and finishing glass in the city's one large factory. Nearly another 1,000 worked in glass cutting and engraving businesses scattered around town. Nowhere else in America were so many people employed in the glass cutting business.

Because Corning was a center for the production of cut glass for nearly a century—from 1868 to 1962—it is entirely appropriate that The Corning Museum of Glass should contain a permanent exhibit focusing on this industry and its impact. The Museum has the pre-eminent collection of cut and engraved glass made in Corning.

Corning was a farming community and rail hub when the owners of the Brooklyn Flint Glass Works moved their business upstate in 1868 to escape the high costs of doing business in New York City. They also persuaded John Hoare to locate a cutting shop on their premises in Corning. The late 19th century was a profitable period for these businesses and for the cutting firm that Thomas G. Hawkes founded in Corning in 1880. The prestige of American cut glass eventually surpassed that of older European firms, helped in no small measure by the gold medal won by Hawkes at the Paris world's fair of 1889.

Most of Corning's first glass craftsmen came from Europe. After 1900, however, many of the workers were American-born and trained in Corning's factories.

Corning-made cut glass was very popular with America's presidents. The Hawkes shop, for example, provided glass for Presidents Cleveland, Benjamin Harrison, McKinley, Franklin D. Roosevelt, Truman, and Eisenhower.

At its peak, around 1900, the Hawkes company employed more than 400 workers. When that firm closed in 1962, Corning's participation in the cut glass industry came to an end.

One of the city's most remarkable glassmakers was Frederick Carder (1863–1963), who served as the first manager of Steuben Glass Works. He also created new glass colors and shapes, pioneered decorative processes, and experimented with early techniques.

Glass window blinds

U.S., Brooklyn or Corning, New York, Brooklyn Flint Glass Works or Corning Flint Glass Works, 1866–1870. L. (each panel) 92.0 cm (69.4.271).

Elias Hungerford received a patent for these glass window blinds in 1866. They were designed, he said, "to give light which enters the room any desired tint to correspond with the color of wall paper and carpets or furniture, thus giving to the room a most pleasing and harmonizing appearance." He insisted that his blinds would never require painting or varnishing, and that they could be produced very inexpensively. Amory Houghton Sr., president of the Brooklyn Flint Glass Works in New York City, agreed to manufacture the blinds. In 1868, Hungerford and some local investors persuaded Houghton to move to Corning and rename his factory the Corning Flint Glass Works. The blinds were not a commercial success, and only a few sets survive. The set shown here came from Hungerford's house in Corning.

Decanter in "Croesus" pattern

U.S., Corning, New York, J. Hoare and Company, silver mounts by Gorham Manufacturing Co., 1887–1897. H. 26.1 cm (95.4.269).

John Hoare was born in Ireland, where he trained as a glass cutter. He came to New York in 1853, and two years later he bought the cutting shop at the Brooklyn Flint Glass Works. In 1868, the glassworks moved to Corning, and Hoare later established a successful cutting firm there. In the 1870s and early 1880s, that firm was one of the largest of its kind in America. Factory records from that period show that it made a wide range of products cut in a variety of patterns. This decanter is cut in the "Croesus" pattern. The pattern was illustrated in the earliest known Hoare catalog, produced about 1890. Hoare supplied a set of tableware for President Ulysses S. Grant in 1873 and won an award at the Chicago world's fair in 1893.

**Vase in
"Venetian"
pattern**

U.S., Corning, New
York, cut by T. G.
Hawkes & Co., about
1890–1900. H. 39.9
cm (97.4.22).

In 1863, another Irishman, Thomas G. Hawkes, started to work for John Hoare in the cutting shop of the Brooklyn Flint Glass Works. When Hoare opened his cutting firm in Corning, Hawkes became its superintendent. However, in 1880, Hawkes left to start his own shop. An astute businessman, he built the largest cutting shop in the area. Hawkes was also a skilled designer. This handsome vase cut in the "Venetian" pattern was made by his firm in the 1890s. Colorless glass was overlaid with a layer of turquoise glass, which was then cut away to reveal the colorless glass underneath. Colored objects dating from this period are relatively rare. Catalogs show wineglasses overlaid with red, amber, and green glass, but no other colors are represented. However, a number of turquoise overlay pieces have been found, and most of them are attributed to Corning firms.

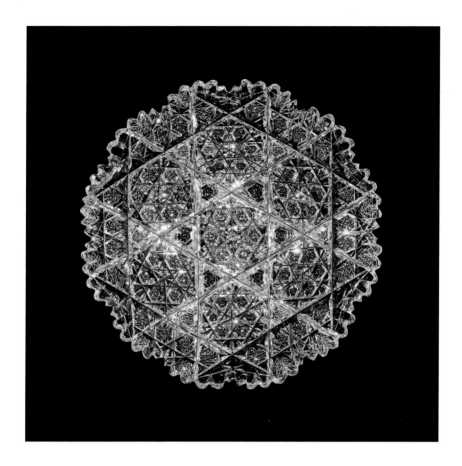

Plate in "Arabian" pattern

U.S., Corning, New York, O. F. Egginton and Company, about 1896–1910. D. 18.0 cm (95.4.274). Gift of Ruth L. Gay, granddaughter of Walter Egginton.

Oliver Egginton, who had served as Hawkes's manager for 15 years, opened his own cutting firm in 1896. When he died just four years later, his son Walter took over the business. Walter had been a Hawkes designer in the 1880s, and according to family tradition, he designed some of the glass that was displayed at the Paris world's fair in 1889. In its early years, which coincided with the peak period of glass cutting, the Egginton firm remained prosperous. It employed as many as 100 men, but by 1918 the company was bankrupt. All of its patterns were designed by Walter Egginton, who preferred heavy brilliant cutting to engraving. One of his patterns, "Arabian," is shown on this plate, which was made near the start of the 20th century.

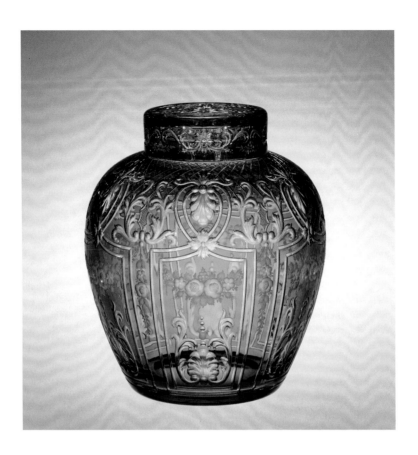

Covered potpourri jar

U.S., Corning, New York, H. P. Sinclaire and Company, about 1926. H. 20.4 cm (84.4.165). Gift of Mrs. Douglas Sinclaire.

H. P. Sinclaire Jr. was the owner of another glass cutting firm in Corning. He got his start as bookkeeper for Thomas Hawkes, who taught him every facet of the business. Sinclaire did not share Hawkes's enthusiasm for richly cut glass, and so he was encouraged to develop his interest in engraving. When Sinclaire later established his own company, he became known at once as the city's engraving specialist. Among its most famous customers were the king of Bavaria, who desired a set of elaborately engraved goblets made from exceptionally thin blanks, and President Warren G. Harding, who purchased two table services for use in his private home in Marion, Ohio. This covered potpourri jar, which Sinclaire designed for his stepmother in 1926, displays engraving that represents the best work done at his firm. The shape of this object is reminiscent of a Chinese "ginger" jar.

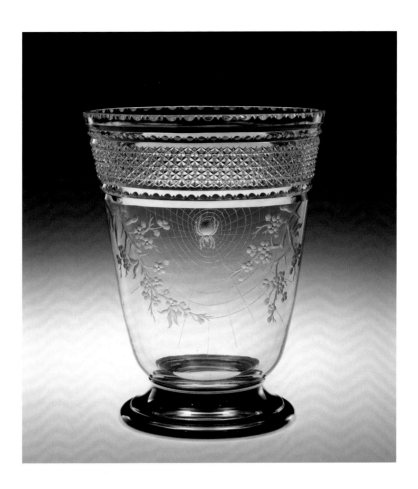

Vase with engraved spider web and silver base

U.S., Corning, New York, T. G. Hawkes & Co., designed by Samuel Hawkes, 1939. H. 23.3 cm (98.4.9).

After Thomas Hawkes died in 1913, his business was operated by his only son, Samuel. Samuel Hawkes, who had joined the firm about 1895, was trained as a businessman and not as a glass cutter. Nevertheless, he became a skillful designer, as this vase with an engraved spider web attests. Hawkes's customers included leading jewelers all over North America, and this piece was made for a traveling exhibition circulated by the Hawkes firm to jewelry stores in 1940 and 1941. It is probably the only example produced in this design. The vase features a silver base. The Silver Department of the Hawkes company created a number of sterling mounts, mostly on "rock crystal engraved" wares. Some of the objects displayed in the jewelry store exhibition were sold at that time, others were donated to a Florida museum, and the remaining pieces—including this vase—were sold from the showroom of Hawkes's Corning store.

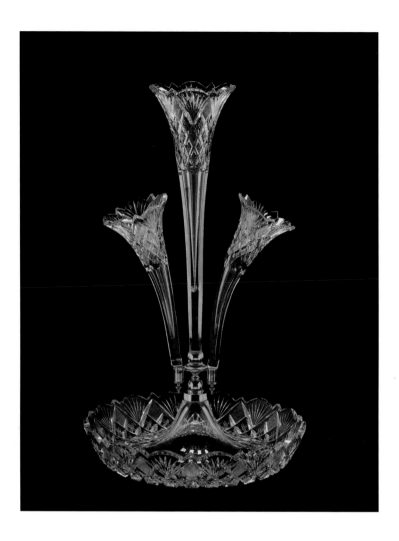

Shower vase

U.S., Corning, New
York, Steuben Glass
Works, designed by
Frederick Carder,
1905–1913. H. 43.1
cm (97.4.21). Gift,
funds from Marvin S.
Shadel in memory of
Elizabeth Shadel.

Frederick Carder never admitted that he admired cut glass. He would say only that "when well designed, cut glass has a brilliancy like no other material except the diamond." He had designed cut glass patterns during his early employment in England, and the popularity of cut glass in America prompted him to establish a cutting shop at Steuben. Responding to popular demand, he sometimes produced pieces that were "cut all over" and "painful to pick up." Most of the cut objects created in Steuben's early years are among the best such works of their time. This shower vase was an elegant centerpiece in the home. Steuben's records indicate that it originally sold for five dollars, and that a similar shape was made with hanging baskets as well as trumpets. Such shapes would have been familiar to Carder even before he left England, but cut flower stands are rare in English glass.

Paperweights of the World

The Corning Museum of Glass houses the world's largest and most comprehensive collection of paperweights. This display presents the finest pieces made by European companies in the 19th century, as well as some outstanding modern examples.

In the mid-19th century, as inexpensive writing paper became available, letter writing was a popular activity. Glassmakers produced thousands of brilliantly colored and intricately designed domed objects to hold down papers on Victorian desks.

The earliest datable paperweights were created in Italy in 1845. Within a decade, a growing fascination with these objects led to their production in France, England, Bohemia, Belgium, Russia, and the United States.

The techniques used in making paperweights were not new. Millefiori (Italian for "thousand flowers") had also been employed by glassmakers in antiquity to present elaborate multicolored floral effects. Lampworking, which was several centuries old, was used to make ornate, lifelike miniature floral designs. Sulphides, molded ceramic plaques encased in glass, had become fashionable only about 50 years earlier. The crystal dome that surrounded all of these designs acted like a lens to magnify the pattern.

Although changing tastes led to a decline in the popularity of paperweights, glassmakers continued to produce them in the late 19th and early 20th centuries. A renaissance in paperweight making began when the Baccarat factory in France created weights to mark the coronation of Queen Elizabeth II in 1953. The Studio Glass movement also fueled this revival. The American paperweight maker Charles Kaziun, for example, rediscovered a number of techniques that had been perfected earlier.

Today, using the latest technology and ultra-clean conditions, glassmakers are redefining the style and decoration of paperweights. While they are still inspired by nature, these artists are creating many new effects.

For students of glass, paperweights hold a special fascination. These exquisite objects may have been only colorful "baubles" when they were new, but today they are remarkable for their purity of material and perfection of execution. They are also prized for the intricacy of their designs and the daring of their color combinations. Paperweights are indeed small masterpieces of the glassmaker's art.

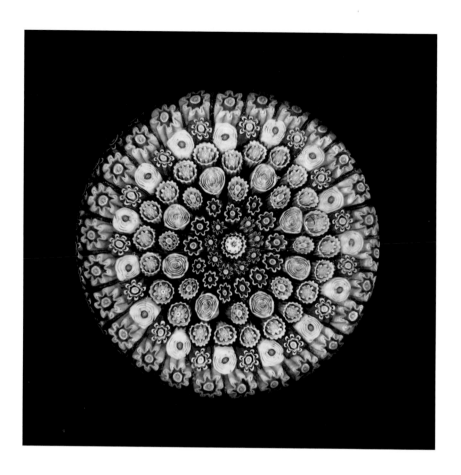

Millefiori paperweight

France, Clichy-la-Garenne, Cristallerie de Clichy, about 1845–1855. D. 8.2 cm (78.3.124). Gift of the Hon. and Mrs. Amory Houghton.

The millefiori technique used in the mid-19th century was probably little different from that perfected by glassmakers in ancient times. Thin colored glass rods, bundled to create a complex design in cross section, were softened and pulled out to form a pencil-thin cane many yards long. After the cane had been annealed, it was cut into individual slices containing the same miniature design. Many slices of different canes could be placed side by side to create a rich carpet that looked like a meadow of wildflowers. Characteristic patterns help collectors identify the makers of paperweights. Pink-petaled roses were a motif frequently used by many manufacturers. At the Clichy factory near Paris, the rose was combined with the company name to form a signature cane.

"Yellow Encased Overlay" paper-weight

France, Saint Louis, Compagnie des Cristalleries de Saint Louis, about 1845–1855. D. 8.0 cm (57.3.186). Gift of the Hon. and Mrs. Amory Houghton.

Encasing a flat bouquet in molten glass is technically challenging, but the difficulty is greatly increased when an upright bouquet is involved. To produce the famous "Yellow Encased Overlay," the glassmaker enclosed a bouquet of large, colorful flowers and leaves in a gather of colorless molten glass and thin white and yellow-green overlays. The weight was annealed, and circular "windows" were cut through the overlays. It was then reheated so that an outer covering of colorless glass could be applied. If the weight was overheated, the double overlay could collapse under the hot glass covering and lose its carefully carved shape. There must have been many such failures in making these complicated weights, for examples are very rare today.

The Saint Louis Gingham

France, Saint Louis, Compagnie des Cristalleries de Saint Louis, about 1845–1855. D. 8.0 cm (95.3.62). Houghton Endowment Fund.

The famous Saint Louis "Gingham" overlay, the only example of its kind known to exist, is a masterpiece from the classical period of French paperweight making. It was probably produced as a prestige piece, designed to demonstrate the skills of the craftsmen, rather than as a commercial work. This weight features a tall bouquet and a double overlay cut in a pattern resembling a gingham fabric. The double overlay was likely achieved by gathering the two overlay colors of glass together and then blowing a bubble. This was folded over the colorless core with the bouquet, enclosing the piece. When the object had been annealed, the opaque overlay colors were cut away with a small wheel to produce the gingham pattern latticework. The weight was then reheated and encased in a layer of colorless glass.

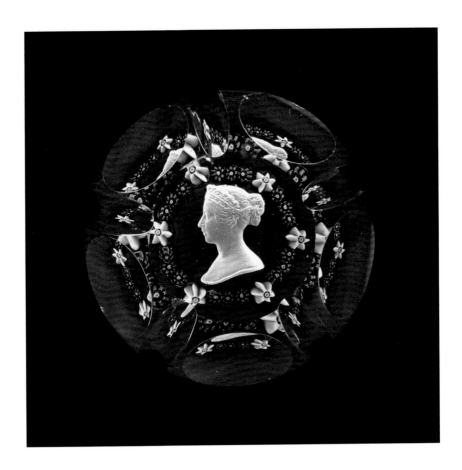

Paperweight with sulphide portrait of the young Queen Victoria

France, Clichy-la-Garenne, Cristallerie de Clichy, about 1845–1855. D. 7.2 cm (72.3.164). Gift of Lucy Smith Battson.

Glassmakers made sulphides by encasing pure white ceramic plaques—usually molded portraits of famous people—in glass. In the 19th century, the most popular subjects were probably Napoleon I and Queen Victoria. Sulphides were tricky to produce. First, the wafer-thin decoration had to be carefully molded, removed from the mold, and dried. Any excess clay had to be trimmed away without damaging the fragile sulphide. It was then fired and, while hot, inserted into a small bubble of molten glass. Finally, the bubble was collapsed around the sulphide by sucking out the air. Some manufacturers poured molten glass directly onto the heated sulphide. It is evident that, however careful they were, glassmakers could not avoid spoiling some of the sulphides. Cracking must have been the most prevalent problem.

**Paperweight
with a pear**

France or Bohemia,
19th century. D. 7.6
cm (95.3.14).

The catalog for a 1978 exhibition of paperweights at The Corning Museum of Glass praised this 19th-century French weight decorated with a pear as "perhaps the most exciting of all fruit weights." The authors also noted that "fruits in paperweights . . . are by process three-dimensional, which may account for the appeal they have for some over flat flower weights." The fine execution and unusually convincing leaves of the pear weight make it an outstanding example of the glassmaker's art. The high dome and the treatment of the ground color are typical of weights made at the Pantin factory near Paris. However, the modeling of the leaves and the pear is similar to that found in weights produced at Saint Louis. Therefore, the pear weight cannot be attributed with certainty to either of these factories.

The Houghton Salamander

France, probably Pantin, Cristallerie de Pantin, about 1870–1880. D. 11.5 cm (55.3.79). Gift of the Hon. and Mrs. Amory Houghton.

Snakes and lizards were fashionable paperweight motifs. The Saint Louis factory produced mold-blown weights featuring lizards curled on top of rounded cushions. Large domes incorporating lifelike lizards or salamanders, made by the Pantin factory in the late 1870s, are among the most impressive paperweights ever created. Today, fewer than a dozen examples are known. One of them is this magnum (extra-large) weight enclosing a lampworked yellow-green coiled lizard. The artist who produced this weight overcame the risks involved in encasing such a delicate and detailed animal in molten crystal, and preserved the exquisite quality of the lampworking. The lizard's body was wheel-cut to simulate scales, and the legs and other details were added. Salamanders, which were thought to be able to survive fire unharmed, were long revered by glassmakers.

Paperweight plaque

Possibly Bohemia (made for the Russian market), late 19th century. H. 14.0 cm (83.3.1). Gift of Arthur Rubloff and Ellen D. Sharpe.

There are only five known examples of plaque paperweights enclosing elaborate floral bouquets. In the past, these important weights were attributed to the Mt. Washington Glass Company in New Bedford, Massachusetts. This attribution was based on a similar lampworking style found in some lead glass floral weights owned by New Englanders. However, none of the plaques can be traced to New England, and none is made of lead glass. These objects may have originated in Russia or Bohemia. One plaque was found in St. Petersburg, and the example shown here is inscribed in Cyrillic. The Russian glass industry was certainly capable of producing such weights. It is documented, for example, that two Russian glasshouses (Mal'tsev and Bakhmetiev) exhibited glass "inkstands, paperweights, and other articles for the writing table" at the 1843 Exhibition of Russian Manufactures in Moscow.

Paperweight with three-dimensional floral sheaf

U.S., Cambridge, Massachusetts, New England Glass Company, about 1850–1874. D. 10.1 cm (78.4.174). Gift of the Hon. and Mrs. Amory Houghton.

A few American glasshouses were quick to capitalize on the popularity of paperweights. Examples from the New England Glass Company and the Boston & Sandwich Glass Company in Massachusetts appeared in 1852, and production there continued through the 1870s. Letters, company invoices, and price lists confirm that these factories made substantial numbers of paperweights. They were frequently created by craftsmen who had been apprentices at Baccarat, Saint Louis, and Murano. These workers copied and revised floral patterns and latticed backgrounds that had been introduced by such French glasshouses as Saint Louis and Clichy. One New England weight features a lampworked bouquet of flowers, fruit, and foliage on a double-spiral white lattice ground.

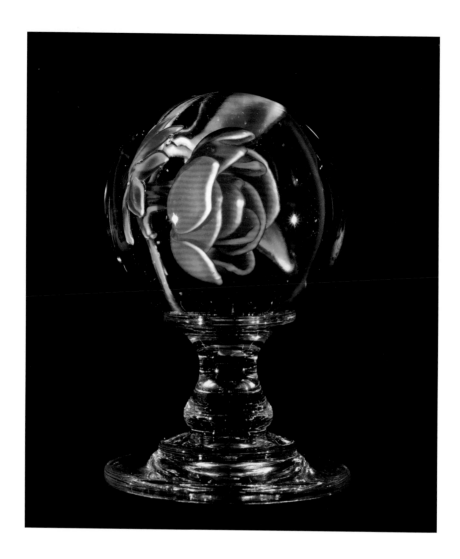

Paperweight mantel ornament

U.S., attributed to Whitall Tatum Company, Millville, New Jersey, probably by Ralph Barber, about 1905–1912. H. 13.7 cm (83.4.69). Bequest of Clara S. Peck.

Most American paperweights with enclosed flowers were made by glassblowers on their own time, using leftover glass. One of the most skillful of these makers was Ralph Barber of Vineland, New Jersey, who created the type of open red rose that is featured in a mantel ornament made in the early 1900s. The rose was formed by applying a pad of red glass to the side of a colorless glass sphere. The glassmaker forced the hot red glass inside the colorless ball with a "crimp" whose curved metal fins were arranged in concentric rings on a wooden handle. As the ball was reshaped, rounded, and covered with another layer of colorless glass, the back of the rose was rounded and closed. A lampworked green stem and leaves completed the decoration.

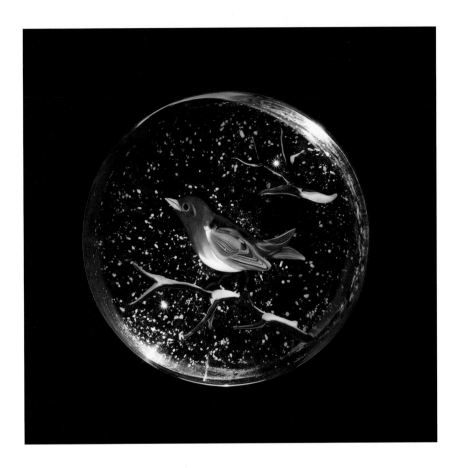

Purple Finch in the Snow

U.S., Nashua, New Hampshire, Roland "Rick" Ayotte, 1982. D. 7.0 cm (82.4.4). Gift of Theresa and Arthur Greenblatt and the artist.

In America, glass paperweights were first made by skilled gaffers in factories for their own amusement or as company products. Today, they are produced as works of art in the private studios of many glass artists. One of them is Roland "Rick" Ayotte, who is known around the world for his realistic representations of birds in glass. Growing up in Nashua, New Hampshire, Ayotte spent many hours exploring the woods and studying animals. In 1978, he started to express his love of wildlife through the medium of glass paperweights, an area of the glassmaker's art that had been dominated by floral motifs and millefiori designs in the 19th century. From 1979 to 1984, Ayotte perfected his lampworking skills, which allowed him to render his subjects with progressively finer detail. Note, for example, the depiction of the wing in the *Purple Finch in the Snow* weight, which combines colorless and polychrome glass.

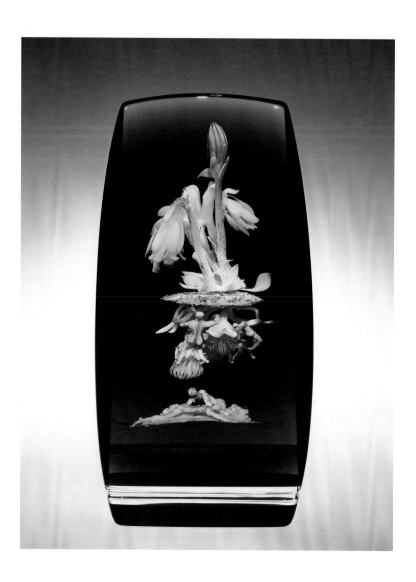

Indian Pipe, from "Cloistered Botanical Series, Tri-Level"

U.S., Mantua, New Jersey, Paul J. Stankard, 1987. H. 19.0 cm (87.4.50). Gift of the Hon. and Mrs. Amory Houghton.

Paul Stankard is one of the world's greatest paperweight makers and lampworkers. In his studio, he strives to reproduce accurately the delicate flora he studies and photographs during walks in the woods near his home. His "Botanical" series displays the entire plant, with soil and roots, three-dimensionally. Indian pipe (*Monotropa uniflora*), also known as corpse plant or convulsion root, grows in moist woodlands in warm and temperate areas of North America, in Japan, and in the Himalayas. The artist's fanciful root system includes "spirit people"—a whimsical touch to an unusual chlorophyll-less, saprophytic plant. The detailed forms embedded in the glass are produced with extremely fine flameworking.

Modern Glass

This gallery shows one-of-a-kind and limited-production art glass vessels, stained glass, furniture, lighting, and decorative objects and accessories from about 1880 to 1960. International in scope, the gallery emphasizes the use of glass as a medium of artistic expression.

After 1900, fine art and design in every medium experienced radical changes. This was especially true for glass. Science, industry, and artists explored unconventional approaches to the material and developed new technologies. These explorations and advances changed perceptions about glass as a medium for art.

"Art" glass is a 20th-century phenomenon that has its roots in the 19th century, when many historic glassworking techniques were revived and a range of new colors was developed. The first art glass is connected with the Arts and Crafts movement in England. This movement, which began in the 1860s, was inspired by the writings of the British philosopher and art historian John Ruskin (1819–1900). Ruskin deplored the social and artistic effects of increasing industrialization, a view that would be shared by many 20th-century artists, architects, and designers.

Art Nouveau (New Art) encompasses various artistic styles that emerged in Europe and the United States during the 1880s, including Arts and Crafts, the Aesthetic movement, Symbolism, and *japonisme*. This movement in architecture and design peaked around 1900 and ended with the onset of World War I. Art Nouveau glass reflects the two styles characteristic of this movement. One was based on natural imagery and emphasized asymmetrical compositions and sinuous lines. The second focused on restrained forms with geometric patterns.

The Art Deco style dominated international design between the two world wars. Its many sources included geometric aspects of Art Nouveau, Cubism, Functionalism, and ancient and tribal art. Art Deco favored classical forms and luxury materials. It emphasized symmetry and angularity over the curving forms of Art Nouveau.

After 1945, styles in art and architecture became increasingly global, rather than national or regional. The design of objects for everyday use gained importance for artists and architects, who wished to emphasize modern ideals of utility, beauty, and affordability. The diversity of artistic styles and the new interest in design are reflected in postwar art glass, which ranges from mass-produced commercial glassware to the production of limited-edition and one-of-a-kind objects.

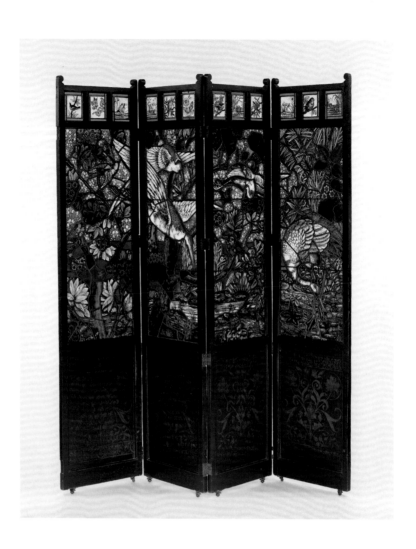

Screen with marsh landscape

England, London, attributed to John Moyr Smith, about 1875–1880. H. 208.3 cm (94.2.12). Clara S. Peck Endowment.

This stained glass and wood screen is a superb example of the art of the English Aesthetic movement, an artistic philosophy and style closely related to the Arts and Crafts movement. The four stained glass panels depict herons, other water birds, and marine wildlife in a lush marsh landscape. Enclosed in painted and stenciled frames of ebonized wood, the panels show the influence of the well-known Arts and Crafts designer William Morris (1834–1896) and his interest in Celtic ornamentation, medieval manuscript illumination, and Japanese decorative arts. The decoration reflects the colorful, dense, and multitextured interiors fashionable in London, as well as the new taste for Japanese art. This screen is attributed to John Moyr Smith (1839–1912), who worked in the London studio of the Scottish designer Christopher Dresser from 1868 to 1871.

Agate vase with silver mount

U.S., Corona, New York, Tiffany Glass and Decorating Co., Louis Comfort Tiffany, dated 1893. H. 44.2 cm (98.4.24). Purchased with the assistance of the Houghton Endowment.

Louis Comfort Tiffany (1848–1933) was the leading proponent of the Art Nouveau style in America. He was influenced by the English Aesthetic movement, which extolled exoticism, and by the Parisian fashion for Japanese art, called *japonisme*. By 1880, Tiffany had amassed a collection of Japanese arms and armor. He soon became interested in the arts of Byzantium, Islam, China, and ancient Egypt, Greece, and Rome, which inspired him. The decoration of this Japanese-style vase shows engraved cranes flying in clouds over chased silver waves. The glass, a dichroic that Tiffany called "agate," reflects different colors in transmitted and reflected light, ranging from a glowing red-orange to a flat greenish yellow. It was probably engraved by Fridolin Kretschmann, a Bohemian craftsman. The inscription on the bottom of the mount, "Columbian Exposition, Chicago, 1893," indicates that this vase was meant for display at the Chicago world's fair, where more than one million people visited Tiffany's exhibit.

Marquetry vase,
Les Pins **(Pines)**

France, Nancy, Emile Gallé, dated 1903. H. 17.8 cm (88.3.31). Purchased with the assistance of the Clara S. Peck Endowment, the Houghton Endowment, and a special grant.

The flowering of the art glass industry, in and around the French town of Nancy, owed much to the ambitions of Emile Gallé (1846–1904). Gallé was the most influential designer in the French Art Nouveau style. He was also a poet and a passionate horticulturist. With his creative vision and financial acumen, he had expanded his father's glass and ceramics factory into a flourishing art industry by the late 1880s. The greatest influence on Gallé's designs for glass was nature, with its infinitely rich colors and textures. He was also impressed by the writings of Romantic and Symbolist poets, who attempted to describe emotions, sensations, and other aspects of the nonvisible world. In this vase, the decoration evokes the humid, spongy layers of a dark, densely wooded pine forest floor. The marquetry technique, patented by Gallé in 1898, involves the complex embedding of decorative elements into the surface of the glass.

144

Window with Hudson River landscape from Rochroane

U.S., Corona, New York, Tiffany Studios, Louis Comfort Tiffany, 1905. H. 346.2 cm (76.4.22).

Stained glass was an essential component of American sacred and secular architecture at the start of the 20th century. The industry was fueled both by the economic boom of the 1870s and by the building of many churches at that time. Louis Comfort Tiffany was internationally known for his stained glass windows, and his Tiffany Studios produced hundreds of them. Although the majority of these windows depict religious themes, the landscape windows best illustrate Tiffany's range as a designer. He was commissioned by Melchior S. Beltzhoover to design this large window for the music room of Rochroane, a Gothic Revival mansion built in Irvington-on-Hudson, New York. The window depicts the Hudson River landscape as seen from Rochroane's hilltop location. The river vista is framed by hollyhocks, clematis, and trumpet vines. By 1970, when Rochroane was donated to the Roman Catholic Church, most of the decorations and furnishings, including this window, had been removed and sold.

Window, *Tree of Life*, from the Darwin D. Martin House

U.S., designed by Frank Lloyd Wright, 1904. H. 100.9 cm (92.4.175). Clara S. Peck Endowment.

The American architect and designer Frank Lloyd Wright (1867–1959) is best known for his residential architecture. Wright aimed to dissolve the boundaries between building and landscape. He also believed in a unity of design, and he paid special attention to details such as windows, which he used to control the quality and play of light in a room. The *Tree of Life* window is Wright's most recognized design for stained glass. Here, he has reduced the tree to its most elemental, geometric form—with a square for the roots, simple straight lines for the trunk, and chevrons for the branches. Leaves are indicated by pieces of gold, red, and green glass. This window was made for the Darwin D. Martin House in Buffalo, New York, which was built in 1905. The house features a low, horizontal silhouette characteristic of Wright's Prairie Style, which evokes the long, flat vistas of the American prairie.

146

Sculptural vessel

Italy, Murano, Artisti Barovier, Umberto Bellotto, about 1914–1920. H. 65.6 cm (95.3.36).

In the early 1900s, the Venetian designer Umberto Bellotto (1882–1940) established a workshop for artistic ironworking, where he produced elaborate grillwork and gates. He was awarded a patent for his "marriage" of iron and glass in 1910. This one-of-a-kind vessel, in the form of a glass "blossom" supported by a foliate wrought-iron stem, is typical of Bellotto's limited artistic production. The metal was forged in his shop, while the glass, decorated with pieces of mosaic glass canes and irregular shards of color, was made by Artisti Barovier. This Muranese firm was noted for its designs in *murrine* (mosaic glass). Working with blown glass stimulated Bellotto's interest in the material, and by the 1920s he was creating designs for Venice's Pauly & C. The organic, flowerlike concept of this sculptural vessel is characteristic of the *stile floreale*, or *stile Liberty*, the Italian interpretation of Art Nouveau.

Covered vase,
Negerhyddan
(The African Hut)

Sweden, Orrefors,
Orrefors Glasbruk,
designed by Edward
Hald, 1918. H. 26.0
cm (68.3.16).

In 1917, the painter Edward Hald (1883–1980) joined the design department of Orrefors Glasbruk, which was directed by the illustrator Simon Gate (1883–1945) and the master glassblower Knut Bergqvist (1873–1953). Since 1913, this Swedish glasshouse had focused on art glass, and by the time of Hald's arrival, it had already developed its famous ruby-tinted *Graal* glass. Gate and Hald, who discussed their proposals at length with the firm's engravers and blowers, made their first designs for engraving on colorless glass in 1917. By 1929, Orrefors employed at least 36 engravers, a fact that attests to the popularity of its engraved glass during the 1920s. While Gate's designs tended to be conservative and classical, Hald, who had studied with Henri Matisse, was a modernist. *Negerhyddan* was the first of Hald's designs in which the engraved illustration was perfectly adapted to the form of the covered vase.

Tableware set

Austria, Vienna,
Wiener Werkstätte,
designed by Josef
Hoffmann, about
1915. H. (tallest)
32.8 cm (74.3.24).

The Viennese architect and designer Josef Hoffmann (1870–1956) deplored the poor quality of mass-produced objects. His preference for well-crafted everyday wares echoed the aims of the earlier Arts and Crafts movement in England. Hoffmann, who belonged to the avant-garde group of Austrian artists known as the Vienna Sezession, founded the Wiener Werkstätte (Vienna Workshop) in 1903. It produced all kinds of decorative arts, from jewelry to complete room decorations. Vienna's Die Fledermaus (The Bat), designed by Hoffmann and others in 1907, is one of the Wiener Werkstätte's most recognized interiors. Inspired by artistic cabarets in Paris and Munich, it promoted the Werkstätte's design philosophy. In glass, Hoffmann's work is characterized by simple, full forms and spare, usually geometric decoration. This set of glasses was probably made at Meyr's Neffe, one of the Bohemian glassworks that fabricated the Wiener Werkstätte's designs.

Vase with birds in foliage

France, Nancy, Aristide-Michel Colotte, about 1928. H. 35.6 cm (94.3.115).

Aristide-Michel Colotte (1885–1959) was a French cutter and engraver who initially worked at the Baccarat glassworks. In 1926, he established a studio at Nancy, where he refined his cutting skills. Colotte worked with heavy blocks of cast crystal that he usually acquired from Baccarat. He sculpted these blocks using a variety of cold-working techniques, such as cutting, acid etching, chiseling, and filing. Colotte carved vessels with abstract, geometric decoration in the Art Deco style, as well as human and animal figures. His first sculptured vessels were exhibited at the 1927 Salon des Artistes Décorateurs in Paris, for which he was awarded the prize "Best Worker in France." This vase, which depicts birds in thick foliage, stands on its original black glass base. It is signed by Colotte with the notation "*pièce unique,*" which means "one-of-a-kind."

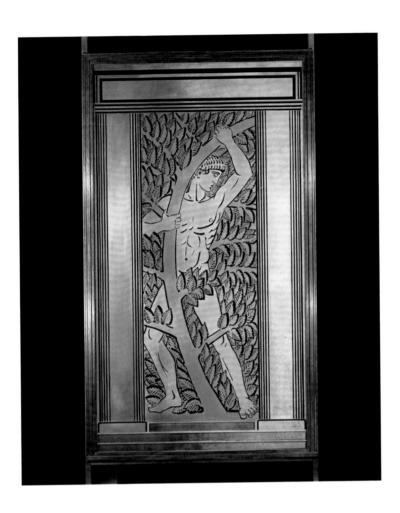

Wall panel

France, Wingen-sur-Moder, R. Lalique et Cie, René Lalique, 1932. H. (frame) 278.1 cm (55.3.165). Gift of Benjamin D. Bernstein.

René Lalique (1860–1945) began his career as a jeweler, and his unusual designs earned him an international reputation. In 1909, he purchased a small glassworks near Paris and started to make perfume bottles. He wanted to produce fine art glass using modern industrial techniques, such as mold blowing and pressing. Lalique's business quickly expanded, and he moved to a larger factory in 1918. There he manufactured a range of art glass, including ornamental objects, vases, and chandeliers. This sandblasted and cut panel, in its original bronze frame, is one of the largest single pieces of Lalique glass in existence. It was one of a set of Art Deco–style glass panels commissioned for the lobby of Wanamaker's Department Store in Philadelphia. Lalique et Cie completed several large commissions in the United States between 1928 and 1935. These included architectural decorations for the Oviatt Building in Los Angeles and the Coty Building in New York City.

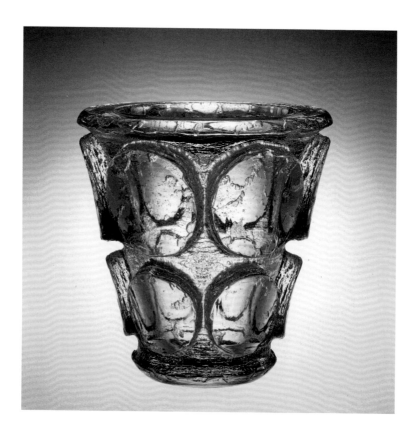

Vase with acid-etched decoration

France, Bar-sur-Seine, Maurice Marinot, about 1934. H. 17.0 cm (65.3.48). Gift of Mlle Florence Marinot.

Maurice Marinot (1882–1960) lived in the French town of Troyes. He studied painting in Paris, where he was deeply impressed by the work of Henri Matisse and André Derain, and he exhibited there regularly from 1905 to 1913. In 1911, Marinot was introduced to glassworking at a factory owned by his friends Eugène and Gabriel Viard. He was intrigued by the material, and he exhibited his first work in glass alongside his paintings. From 1913 to 1937, Marinot worked after-hours at the Viards' factory, where he composed his designs and blew, acid-etched, cut, and enameled the glass himself. Because Marinot was a painter rather than a factory glass-blower, his love of glassworking, as well as his access to hot-glass facilities, was unusual. Today, his role as an artist and a glassworker is widely respected, and he is regarded as a pioneer in studio glass.

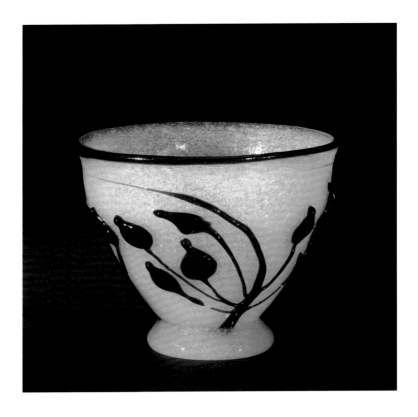

Footed bowl

France, Paris, Jean
Sala, about 1930–
1940. H. 7.9 cm
(75.3.15).

Another pioneer of studio glassmaking was Jean Sala
(1895–1976), the son of a Catalonian glassworker. In 1904,
the Sala family moved from Spain to France, settling in Par-
is. Sala set up his own hot-glass facility in Montparnasse
around 1920. He melted his glass at a small furnace that he
fanned with a hand bellows, and he blew small vessels and
glass animals by himself. Sala used a bubbly, porous glass
that he called *malfin* (coarse) because it resembled the weath-
ered surfaces of ancient glass. He also created works in *pâte
de verre* (glass paste), which involves grinding glass to a pow-
der, adding a binding agent, and casting and firing the mix-
ture in a mold. Sala worked on his own until about 1938,
when he joined the Saint Louis glassworks as artistic director.
In 1945, he returned to his studio, where he made his own
glass until 1951. This small bowl with applied decoration was
blown by Sala in *malfin* glass.

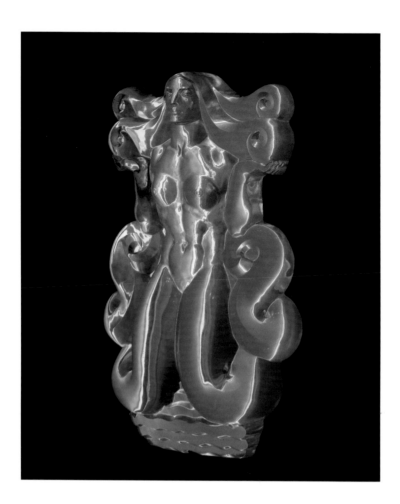

Atlantica

U.S., Corning, New
York, Steuben Glass
Incorporated, Sidney
Waugh, 1938–1939.
H. 94.5 cm (72.4.222).
Gift of Corning Glass
Works.

Steuben Glass Works was founded in Corning in 1903 by the English glass designer Frederick Carder and the American cut glass manufacturer Thomas G. Hawkes. In 1918, the company was sold to Corning Glass Works. Carder was Steuben's manager until 1932, and Arthur Amory Houghton Jr. became president of the firm in 1933. The highly refractive glass now characteristic of Steuben was developed in 1930. It inspired Houghton to shift Steuben's production from colored glasses to heavy blown and engraved wares. *Atlantica* was created for the 1939 New York World's Fair. Conceived by Steuben designer Sidney Waugh (1904–1963), this 300-pound sculpture of a mermaid riding on the waves of the Atlantic Ocean commemorates the start of glassmaking in America by European immigrants. *Atlantica* required a team of five glassworkers to pour the molten glass into the sculpture's mold. Another three workers polished the sculpture, which took several months to complete.

Dish

Finland, Iittala,
Karhula-Iittala Glass
Works, Tapio Wirk-
kala, about 1952.
D. 30.5 cm
(61.3.319).

During the 1950s and early 1960s, Scandinavian and Italian design in all media was internationally popular. In glass, the concepts of utility, beauty, and affordability—the hallmarks of modern design—were fully exploited in Sweden and Finland. One of the most influential Finnish designers at this time was Tapio Wirkkala (1915–1985). In 1946, he was hired by Finland's Iittala Glass Works, where he created sophisticated works that blurred the line between functional object and sculpture. Taking his inspiration from the northern landscape, Wirkkala favored abstract shapes in thick, transparent, icelike chunks of glass. While international interest in Scandinavian design started to wane in the 1960s, Wirkkala's influence remained strong. He continued to make popular designs for glass and furniture. A series of colorful plates and bottles, created in the late 1960s for the Venini glassworks in Italy, earned him further international recognition.

Fazzoletto (hand-kerchief) vase

Italy, Murano, Venini, Paolo Venini and Fulvio Bianconi, de-signed in 1949. H. 23.8 cm (51.3.139).

The Venini glassworks was founded in 1921 by Paolo Venini (1895–1959) and the Venetian antiques dealer Giacomo Cappellin. The company's first artistic director, Vittorio Zecchin, established a new, bold, and very modern look for Venetian glass that was immediately popular. Venini was among the few Italian manufacturers of applied art invited to exhibit at the landmark 1925 Exposition des Arts Décoratifs et Industriels Modernes in Paris. It was the only glassworks on Murano to invite outside artists, designers, and architects to work on its premises. Paolo Venini infused Muranese glassmaking with new life, and under his guidance, the firm's artistic directors helped to revolutionize glass design in Italy. The *fazzoletto* (handkerchief) vase, created by Paolo Venini and his artistic director, Fulvio Bianconi (1915–1996), was one of Venini's most popular designs. This example is made in *zanfirico* glass, an Italian style of cane decoration that is generally called *filigrana* (filigree).

Vase with cut decoration

Czechoslovakia, Prague, Art Center for Glass Industry, Pavel Hlava, 1958. H. 38.7 cm (62.3.128).

In Czechoslovakia, a concentrated effort was made to institute new glassmaking programs during the late 1940s and 1950s. These programs were associated with professional schools in Prague (the Academy of Applied Arts) and regional cities such as Železný Brod, Kamenický Šenov, and Nový Bor. Czech glass was influential throughout Europe, and after 1945, Czech design was recognized for its originality. The postwar years were a creative time for Czech glassmakers, as they were for the Italians and Scandinavians. Technical schools, and their relationship with state-owned factories, afforded individual artist-designers the opportunity to use hot glass. Pavel Hlava (b. 1924) trained in Železný Brod and at the Academy of Applied Arts. For 20 years, he was chief designer at Crystalex, where he created some of the company's most popular designs. Hlava's work gradually developed from purely functional glassware designs to more abstract forms, such as this sculptural vase.

Fused vessel

U.S., Chicago,
Illinois, Frances
Stewart Higgins,
about 1958–1959.
H. 23.5 cm (86.4.8).

Before the development of the Studio Glass movement, artists conducted limited experiments with hot glass in their own studios, preferring warm glass processes such as kiln fusing and slumping. During the 1950s and 1960s, some artists and designers, who called themselves "designer-craftsmen," explored innovative uses for fused glass and enamels. One of them was Frances Stewart Higgins (b. 1912). She and her husband, Michael, produced a wide range of commercial tableware and one-of-a-kind objects. From 1957 to 1966, the Higginses contracted with the Dearborn Glass Company in Illinois to produce their designs, but they continued to make work in their studio. This experimental vessel anticipates the trend in nonfunctional vase forms characteristic of the early Studio Glass movement. It was made by heating pieces of crushed colorless glass until they fused but still retained their original shape. The vessel is decorated with a simple strip of gold and white enamel.

Glass after 1960

The Studio Glass movement, the last and most energetic art glass movement of the 20th century, is the focus of this gallery. It features vessels, objects, sculpture, stained glass, furniture, and lighting that date from the late 1960s to the early 1990s.

After 1960, art glass was dramatically transformed. Artists began to make a wide range of glass in their studios, outside the factory. Ideas changed about how glass was crafted, and artists envisioned alternative uses for glass in art. These new perspectives resulted in the burst of artistic activity that is known as the Studio Glass movement. Unlike most artistic movements, the Studio Glass movement is an open, international movement that is defined by its medium rather than by a philosophy or style.

Studio artists practiced warm and cold glassworking processes throughout the 20th century. These processes included kiln fusing and making leaded and stained glass. However, the development of the portable glass furnace enabled many more artists to explore hot processes, such as glassblowing, which galvanized studio glassmaking.

It is generally agreed that the Studio Glass movement began in 1962 during two seminal glassblowing workshops held at The Toledo Museum of Art. These workshops were led by the ceramist Harvey Littleton and the glass research scientist Dominick Labino. After the Toledo workshops, news of the "new" art medium swept through American art schools and universities, where Littleton, his students, and other pioneering artists began to institute glass programs.

By 1971, there were more than 25 university programs in glass, as well as summer programs at the Haystack Mountain School of Crafts, the Penland School of Crafts, and the Pilchuck Glass School. American artists moved around the country with portable furnaces, demonstrating glassblowing at college campuses, artists' studios, conferences, and craft fairs. The strong community of artists, educators, collectors, writers, and dealers that distinguishes the Studio Glass movement has its roots in this activity.

The Studio Glass movement is distinguished from other 20th-century art glass movements by its emphasis on the artist as designer and maker, its focus on the making of one-of-a-kind objects, and its international character. Another of its distinguishing features is a sharing of technical knowledge and ideas among artists and designers that would not be possible in an industrial environment. Originally an American phenomenon, the Studio Glass movement spread quickly to Europe, Australia, and Asia.

**Upward
Undulation**

U.S., Spruce Pine,
North Carolina,
Harvey K. Littleton,
1974. H. 161.5 cm
(79.4.145). Pur-
chased with the aid
of funds from the
National Endowment
for the Arts.

Harvey Littleton (b. 1922), son of the Corning Glass Works scientist Jesse Littleton, was a teaching ceramist before he turned his attention to glassblowing. Inspired by the pioneering work in ceramics of the California potter Peter Voulkos, Littleton started experimenting with hot glass in his studio in 1958. His efforts culminated in the 1962 Toledo glassblowing workshops, which he led with Dominick Labino. Littleton then initiated a glass program at the University of Wisconsin in Madison. Glass programs were subsequently introduced into art school curricula nationwide, initially through Littleton's energetic and talented students. Littleton's sculpture is characterized by rounded, thick blown shapes, often of alternating layers of color. *Upward Undulation*, made of slumped sheet glass, is an unusual example, but it is typical of the artist's interest in capturing the dynamic, fluid quality of glass.

***Emergence
Four-Stage***

U.S., Grand Rapids,
Ohio, Dominick
Labino, 1975. H.
22.4 cm (76.4.21).
Purchased with the
aid of funds from
the National Endow-
ment for the Arts.

At the time of his partnership with Harvey Littleton, Dominick Labino (1910–1987) was vice president and director of research at the Johns-Manville Fiber Glass Corporation in Ohio. Labino's expertise in batching (formulating and mixing the raw materials to make glass) and melting supported Littleton's experiments in working the material. At the first Toledo workshop, it was discovered that the initial batch of melted glass was unworkable. Unwilling to abandon the project, Littleton sought Labino's help. Labino provided the workshop with some of his fiberglass marbles, formulated to melt at low temperatures, and suggested ways in which the furnace format could be converted. The technical adjustments worked, and Littleton and Labino introduced the first handful of studio artists to their "new" material, glass. *Emergence Four-Stage* is a classic example of Labino's multicolored sculpture with internal veiling. This technique, which he developed, has become iconic of the first decades of the American Studio Glass movement.

Marvin Lipofsky (b. 1938) founded the glass program at the University of California at Berkeley in 1964, and he taught there until 1972. In 1967, he started another glass program at the California College of Arts and Crafts in Oakland, which he directed until 1987. Lipofsky was one of Harvey Littleton's first graduate students in the sculpture program at the University of Wisconsin in Madison. He was also one of a pioneering group of artists who raised awareness of the Studio Glass movement around the world. Although it was essential for artists to learn technique, Lipofsky and other progressive glass artists shifted their focus to the execution of artistic ideas in glass. They searched for ways to subvert the traditional associations between glass and functionality by exploring sculptural forms. This early and influential sculpture is blown, cut, sandblasted, painted, flocked, and assembled. It illustrates the Studio Glass movement's emphasis on unconventional forms and materials.

Teapot and Cozy

U.S., Berkeley, California, Richard Marquis, with the assistance of Ro Purser and Rafaella del Burgo, beaded leather cozy by Nora Faushell of Chubbie's Bakery, 1973. W. 16.1 cm (75.4.29).

Richard Marquis (b. 1945) is another pioneering artist who has made a lasting impact on the Studio Glass movement. In the 1960s, he studied with Marvin Lipofsky at Berkeley, where he worked in ceramics before taking up the glassblower's pipe. Marquis was dissatisfied with what he saw being taught in the United States, so he traveled to Murano in 1969 to observe and work with the island's famed master glassblowers. A couple of weeks at the Salviati furnace was followed by months spent at Venini, one of the premier producers of modern Italian design. Marquis freely shared his knowledge of the glassworking techniques he studied in Venice, instructing students in workshops around the world. *Teapot and Cozy* illustrates the blown *murrine* technique that he learned at Venini. However, the concept and execution of this nonfunctional teapot and beaded cozy are quintessentially American.

The Corning Wall

U.S., Stanwood, Washington, and Providence, Rhode Island, Dale Chihuly and James Carpenter, with the assistance of Darrah Cole, Kate Elliott, Phil Hastings, and Barbara Vaessen, 1974. H. 199.4 cm (74.4.186).

Dale Chihuly (b. 1941) has made an extraordinary contribution to the development of the Studio Glass movement. After studying with Harvey Littleton at Madison, Chihuly established an influential glass program at the Rhode Island School of Design, where he taught until 1983. In 1971, he was a co-founder of the Pilchuck Glass School in Washington State. This panel was started at Pilchuck during the summer of 1974 and completed at the Rhode Island School of Design. Instead of putting together a traditional stained glass window, Chihuly and James Carpenter (b. 1949) blew multiple elements that were then cut, assembled, and leaded. This combination of cold (cutting and assembling) and hot (blowing) processes, and the integration of sculptural (three-dimensional) elements in a flat (two-dimensional) panel, was experimental at the time. Chihuly and Carpenter also included a reference (in the initials "F.L.," for "flood line") to the devastating flood that swept through Corning in 1972.

Innerland

U.S., Corning, New York, Steuben Glass, Eric Hilton, cut by Mark Witter, engraved by Ladislav Havlik, Lubomir Richter, Peter Schelling, and Roger Selander, 1980. W. 49.3 cm (86.4.180). Anonymous gift.

Innerland is a multipartite glass sculpture that expresses designer Eric Hilton's concept of the unity of life and of the "inner being, or inner land, which is shared by all people everywhere." The complex design and flawless execution of this exceptional sculpture make it one of Steuben's greatest achievements. The highly refractive quality of Steuben glass was exploited by Hilton in this crystal landscape, with its dreamlike topographical features that are meticulously engraved, cut, and sand-sculpted. Four years in the making, the sculpture offers an opportunity for meditation on a mystical, inner world, an enchanted microcosm to discover and explore. Eric Hilton (b. 1937), who studied at the Edinburgh College of Art, has taught at universities in Scotland, England, the United States, and Canada. He continues to produce designs for Steuben.

Cityscape

U.S., San Francisco,
California, Jay
Musler, 1981. D.
45.6 cm (82.4.8).

For *Cityscape*, Jay Musler (b. 1949) chose a spherical container blown of industrial Pyrex glass, which he cut in half. He then cut the rim of the hemisphere into a jagged edge, sandblasted it, and airbrushed it with oil paint. *Cityscape* evokes an urban landscape at sunset, the profiles of buildings uniformly darkened by the setting sun glowing red-orange in the distance. Although Musler is best known for his sculpture assembled from pieces of painted flat glass, *Cityscape* is one of his most widely recognized works. It is an excellent example of how studio glass artists have interpreted traditional domestic glass forms, such as the functional bowl, as sculpture. In an effort to dissociate sculpture in glass from craft, many contemporary artists have avoided using traditional containers. However, in *Cityscape*, the viewer respects the interior space as nonfunctional. The sculpture's relatively large size and its combination of decorative techniques reflect new trends in studio glassmaking in the 1980s.

Melancholia

U.S., Oakland, California, Narcissus Quagliata, 1981–1982. W. 142.2 cm (87.4.17). Gift in part of John Hauberg, Anne and Ronald Abramson, and the artist.

In 1961, Narcissus Quagliata (b. 1942) left his native Rome and traveled to San Francisco to study painting. Inspired by the atmosphere, colors, and light of California, he gradually abandoned his canvases in favor of glass. During the early 1970s, Bay Area artists were manipulating stained glass in innovative and experimental ways. Quagliata's bold, figural style translated well into stained glass, as did his interest in the natural world. His work was widely recognized by the early 1980s, and he played an influential role in defining new directions for two-dimensional art using stained glass. In this panel, a man wearing sunglasses and 1970s-style clothing is sitting in an airplane. The image evokes memories of leaving loved ones or loved places—memories that are shared by the artist and the viewer. The representation of contemporary subjects, rather than decorative patterns or historical or ecclesiastical themes, is one of the features that distinguish studio flat glass from traditional stained glass.

While glassblowing was the first focus of studio glass art-
ists, it was not long before other glassworking techniques were
explored. Craftspeople and scientific glassblowers dominat-
ed the field of flameworking, or lampworking, during most of
the 20th century. Like stained glass, flameworking carried a
wealth of craft associations that artists needed to redefine.
Ginny Ruffner (b. 1952), who was trained as a painter, was
the first to exploit the potential of flameworking for making
large-scale sculpture in glass. While small-scale framework-
ing was traditionally executed with soft, soda-lime glasses,
Ruffner adapted her knowledge of harder, borosilicate glass-
es, commonly used in scientific glassmaking, to art. She
challenged glassblowers with the size of her quixotic, upbeat
sculptures that she sandblasted and covered in paint and pas-
tels. *Eat Your Hat* is an excellent example of Ruffner's early,
abstract work, which, unlike her later work, is not overtly
narrative or symbolic.

Until the 20th century, stained glass was used primarily for windows, usually in religious contexts. The tremendous public interest in stained glass during the early 1900s encouraged designers such as Louis Comfort Tiffany to expand its customary uses. In the late 1960s, a revival of American stained glass was sparked by renewed interest in the Art Nouveau style. Many artists began to experiment with two-dimensional glass. By the 1980s, the making of flat glass panels was no longer tied to architecture or to conventional materials. Judith Schaechter (b. 1961) uses the traditional stained glass techniques of cutting, staining, and layering for her narrative images. Her contemporary and sometimes disturbing subjects reflect events that, through the news media, have become commonplace in our lives, such as domestic violence and natural disasters. Schaechter's Punk/Gothic style recalls the anxious yet beautiful figures of medieval art, as well as modern German Expressionist painting.

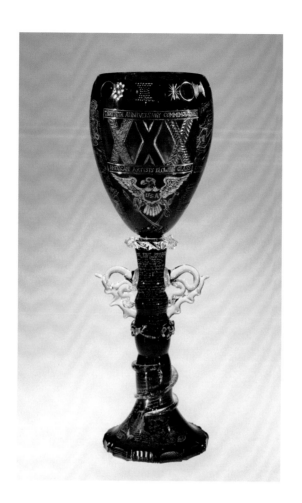

Commemorative Pokal Celebrating the 30th Anniversary of the 1962 Toledo Glass Workshops and Fritz Dreisbach's 30 Years of Working with Glass

U.S., Seattle, Washington, Fritz Dreisbach, with the assistance of Lark Dalton, 1993. H. 54.8 cm (93.4.26). 1993 Rakow Commission.

This *Pokal* (presentation goblet) was inspired by the large toasting vessels made in Germany from the 17th to mid-19th centuries. These vessels were often decorated with elaborate motifs and inscriptions. A studio glass pioneer, Fritz Dreisbach (b. 1941) is also an influential teacher, artist, and historian who has spent much time documenting the American Studio Glass movement's early years. The *Pokal*'s inscriptions chronicle important names and events in the history of studio glass. Images include the American eagle holding a blowpipe, jacks, ladle, and shears in its talons; Dominick Labino's furnace for melting glass; and the hot shop at the Pilchuck Glass School. The eagle refers to the important role American artists played in the genesis of studio glass, while Labino's furnace honors the Toledo workshops. The Pilchuck hot shop represents the sharing of information and the achievement of all artists who have cultivated glass as a medium for contemporary art.

Sculpture Gallery

The Sculpture Gallery presents contemporary art in glass and mixed media dating from the late 1960s to the present. Most of the works displayed are nonfunctional and range from large-scale sculpture to small-scale objects and vessels.

A major development of the Studio Glass movement has been the use of glass, often in combination with other materials, for large-scale sculpture and installations. Since 1980, there has also been a dramatic increase in the size of objects and vessels. The primary function of the Sculpture Gallery is to present large works of contemporary art in glass, yet this space is not restricted to sculpture and installations. It also contains smaller objects and nonfunctional vessels in a variety of glassworking techniques, such as blowing, casting, kiln-forming, flameworking, laminating, stained glass, beading, and assemblage.

This gallery demonstrates the different ways in which glass is used as a medium for contemporary art. The display features unique objects rather than limited-edition or mass-produced works. It is an international grouping, and most of the objects were made during the last two decades. While certain sculptures (and the majority of those featured in this book) will nearly always be on display, many of the art works will be rotated regularly to allow more of the Museum's collection to be exhibited.

The Sculpture Gallery reflects the shifting boundaries between contemporary craft and contemporary art. This phenomenon is not limited to glass. It includes other traditional craft media, such as ceramics and fiber. As artists have experimented with these materials, gaining knowledge of their properties and potential, they have gradually extended their use from the realm of craft into that of art. While art and craft are rooted in the same source—the process of making—there are key differences. In the most general sense, craft emphasizes exemplary technique, function, and the individuality of the object (as opposed to design, which stresses function, form, and reproducibility). Art, on the other hand, is traditionally nonfunctional. It focuses on content that is meant to stimulate thought, memories, or emotions.

Several of the objects in this section, as well as the work presented on the facing page, were created as Rakow Commissions. This award, presented annually by the Museum, was established to encourage the development of new works of art in glass. The commission is made possible through the generosity of the late Dr. and Mrs. Leonard S. Rakow.

Gyes Arcade

U.S., New York, New York, Christopher Wilmarth, 1969. W. 195.6 cm (2000.4.53). Purchased in honor of Susanne K. Frantz with funds provided by the Ben W. Heineman Sr. Family; Roger G. and Maureen Ackerman Family; James R. and Maisie Houghton; The Art Alliance for Contemporary Glass; The Carbetz Foundation; The Maxine and Stuart Frankel Foundation; Daniel Greenberg, Susan Steinhauser, and The Greenberg Foundation; Polly and John Guth; and The Jon and Mary Shirley Foundation.

Christopher Wilmarth (1943–1987) is widely recognized for his poetic sculpture in glass and steel. From 1969 to 1980, he taught at The Cooper Union for the Advancement of Science and Art in New York City. He also taught at Yale, Columbia, and the University of California at Berkeley. In 1969, glass was rarely used in contemporary art, especially large-scale art works. However, the American Studio Glass movement was gathering momentum, and studio glass artists looked at sculpture, such as *Gyes Arcade*, for inspiration on how glass might be treated artistically. Wilmarth saw glass as a solid manifestation of light. The flat and curved commercial plate glass elements of *Gyes Arcade*, which are cut, acid-etched, stacked, and balanced, form an abstract floor composition that reflects light (clear elements) and absorbs it (etched elements). Other contradictions are apparent in the glass itself (the material's strength and fragility) and in the composition (seemingly casual but complicated to assemble).

Eight Heads of Harvey Littleton

Federal Republic of Germany, Frauenau, Erwin Eisch, 1976. H. 50.3 cm (76.3.32).

Erwin Eisch (b. 1927) is a painter and sculptor whose original work in glass made a profound impression during the formative years of the Studio Glass movement. Eisch met the studio glass pioneer Harvey Littleton in 1962. Through their friendship, an important link was established between European and American studio artists working in glass. *Eight Heads of Harvey Littleton* is Eisch's multiple portrait of Littleton. Each mold-blown and enameled head represents a different aspect of the artist's personality. These heads, from left to right, are titled *Littleton the Spirit*; *Littleton the Gentleman*; *Littleton the Fragile*; *Littleton, Man of Frauenau*; *"Technique Is Cheap"*; *Littleton's Headache*; *Littleton the Poet*; and *Littleton the Worker*. *"Technique Is Cheap"* refers to Littleton's widely quoted aphorism that urged artists to concentrate on the artistic content of their work, rather than on glassworking techniques.

Unknown Destination II

U.S., Stanwood, Washington, Bertil Vallien, cast at the Pilchuck Glass School with the assistance of William Morris and Norman Courtney, 1986. W. 104.5 cm (87.4.19).

Bertil Vallien (b. 1938) was trained as a ceramist. Early in his career, he was influenced by the innovative work of American studio potters such as Peter Voulkos. In 1963, Vallien began to work as a designer for the Åfors Glassworks in Småland, the center of the Swedish glassmaking industry. At Åfors, now a subsidiary of the well-known Kosta glass company, he produced designs for everyday objects, limited-production art glass, and unique works. He supported the involvement of artists in the factory, and he championed handcraft over the machine. In the mid-1960s, Vallien made his first experiments with sand casting glass. He later introduced this technique at Åfors and taught it to students in workshops around the world. With sand casting, Vallien was able to translate his sculptural ideas into glass. *Unknown Destination II* reflects his interest in boats, which he uses as a metaphor for the journey (both physical and psychological), time, exploration, and self-discovery.

Dedicant #8

U.S., Providence,
Rhode Island,
Howard Ben Tré,
1987. H. 121.6 cm
(87.4.57). 1987
Rakow Commission.

Howard Ben Tré (b. 1949) is another artist who works in
cast glass. His large-scale and small-scale sculptures are in-
spired by elements of architecture and industry, such as col-
umns, heavy stone fragments, ancient monoliths, and ma-
chine parts. However, their massiveness suggests cast metal
rather than glass. Like architecture, Ben Tré's solid, monu-
mental forms create space rather than decorate it. In *Dedi-
cant #8*, the artist produces a visual tension between the
shape of the sculpture, which is blocky and semi-industrial,
and its tactile surface and luminous color. Bars of carved and
gilded lead, inserted into the glass mass, transform the object
into an altarlike monument with ritualistic implications. In
this work, Ben Tré embellishes and elevates the inanimate ob-
ject by infusing it with the energy of precious materials. Cast
in an industrial glass factory in New York City, the sculpture
was finished in the artist's studio.

Damaged Bone Series, R.V.N. Harris: No Place Left to Hide

U.S., New York, New York, Michael Aschenbrenner, 1989. Dimensions variable (90.4.18).

During the past decade, the combination of glass with other materials—such as metal, stone, clay, wood, textiles, and organic materials—has been of increasing interest to artists working with glass. In his wall sculptures made of glass and mixed media, Michael Aschenbrenner (b. 1949) explores the fragility of the human body. The context in which he works, however, is not symbolic but political. Aschenbrenner served as a medical field technician during the Vietnam War, and his work addresses the physical consequences of war and the trauma of human casualties. In his *Damaged Bone Series*, translucent glass bones are delicately attached by thin wires or carefully bound with rags and supported by wood splints. The reverence with which the bones are treated, as well as their deliberate presentation as relics, is a mute reminder of the transience of existence and the horror of the battlefield.

Water Lilies #52

U.S., Long Island, New York, Donald Lipski, 1990. H. 29.0 cm (92.4.5). Gift of Maureen and Roger Ackerman.

Donald Lipski (b. 1947) is well known for his mixed-media installations and sculptures that question the conventional definitions of art. This artist does not always use glass, but prefers to explore a variety of materials. Much of his recent work examines the properties of organic materials and the operation of ecological systems, which are presented in an industrial, pseudo-scientific context. Lipski favors heavy-duty industrial and scientific glasses that are manufactured by companies such as Corning and Schott. He uses the thick-walled, acid-resistant tanks, spheres, and tubing to enclose and preserve delicate and ephemeral substances, such as plants. *Water Lilies #52* functions as a kind of still life that uses actual vegetables instead of paint. In this sculpture, a bunch of carrots floats inside industrial glass tubing, hermetically sealed with a heavy steel clamp. The preservative solution keeps the carrots in suspended animation, with only their color gradually fading over time.

Clear Lumina
with Azurlite

U.S., Plainfield, Massachusetts, Thomas Patti, 1992. H. 10.3 cm (94.4.1). Gift of The Art Alliance for Contemporary Glass, the Creative Glass Center of America, Ben W. Heineman Sr. Family, and Carl H. Pforzheimer III.

Thomas Patti (b. 1943) was trained as an industrial designer. His studies included research into theories of architecture and perception. This artist is widely respected for his interest in the scientific properties of glass and his intense focus on technique and aesthetic. His complex and precisely engineered sculptures, such as *Clear Lumina with Azurlite*, appear monumental, even architectural, but in reality they are quite small. They seem almost as if they could be models for full-scale architectural commissions, which Patti also undertakes. In this sculpture, all of the effects were created at the interior of the rectangular block during the heating and cooling processes. The block consists of multiple layers of laminated glass, ranging in hue from colorless to blue, over planes of amber and black. A large, seemingly liquid air bubble pushes up from the base and passes through rings and veils of minute air traps. This effect is achieved through the careful manipulation of air and heat.

Three Graces Oblivious while Los Angeles Burns

U.S., Baltimore, Maryland, Joyce Scott, 1992. H. 53.8 cm (97.4.214).

Beads have been generally ignored as a material for art works. Traditionally regarded as a woman's pursuit, beadwork is usually associated with jewelry and other decorative applications, especially in ethnographic and folk art. In her neckpieces, objects, and installations, Joyce Scott (b. 1948) explores the potential of beads for sculpture. She favors political themes not usually associated with beadwork, such as civil rights and other issues affecting women and African-Americans. *Three Graces Oblivious while Los Angeles Burns* was created in response to the violent beating of Rodney King by police officers in Los Angeles, and the citywide rioting that followed their acquittal in April 1992. The policemen were later retried and convicted by a federal judge. Beneath the head of an African-American, the three Graces—who represent gracefulness, peace, and happiness—stand with their backs to burning city buildings. The freestanding figures are knotted and woven around a columnar glass vessel.

Red Pyramid

Czechoslovakia, Železný Brod, Stanislav Libenský and Jaroslava Brychtová, 1993. W. 119.5 cm (94.3.101). Gift of the artists.

The artistic partnership of Stanislav Libenský (b. 1921) and Jaroslava Brychtová (b. 1924) has had an enormous influence on the Studio Glass movement. This husband and wife team has been collaborating on large-scale cast glass sculptures for 40 years. Charcoal studies of the forms are created by Libenský and given to Brychtová, who translates her husband's drawings into three-dimensional models. The process of conceiving each sculpture—developing the concept, envisioning the form in three dimensions, and selecting the color of the glass to be used—is shared by the artists. While much abstract art can seem cold or removed, the sculptures of Libenský and Brychtová communicate emotion and energy through color and light. *Red Pyramid* was presented to The Corning Museum of Glass at the time of the artists' retrospective exhibition in 1994.

Hopi

U.S., Seattle, Washington, Lino Tagliapietra, 1996. H. (taller) 69.2 cm (96.4.166). 1996 Rakow Commission.

Lino Tagliapietra (b. 1934) is another European artist who has made a lasting impact on studio glass, primarily in glassblowing. Working as an assistant and then as an apprentice in the factories on Murano, Venice's famous glassmaking island, he earned the title of *maestro* at the age of 21. In 1979, he traveled to the United States to teach at the Pilchuck Glass School. This was the beginning of an international career and collaborations with noted European and American artists working in glass. After working in the United States and abroad for 10 years, Tagliapietra made the difficult decision to change his artistic path from design to the production of unique works. Rethinking his craft, he emerged in the 1990s as an influential artist. *Hopi* is inspired by the indigenous art of the American Southwest. Its bold and constrasting colors, broad-shouldered forms, and intricate surface pattern recall the Native American ceramics, basketry, and textiles that Tagliapietra admires.

The Glass Wall

England, London, Brian Clarke, glass fabricated at Franz Mayer Inc., Munich, Germany, 1998. L. 22.4 m (99.2.4).

Trained as a painter, Brian Clarke (b. 1953) is well known for the architectural stained glass he has designed for secular and sacred buildings around the world. Through his painterly use of color and light, Clarke designs distinctive stained glass walls that introduce energy and vitality into the architectural spaces they inhabit. *The Glass Wall*, which measures more than 1,000 square feet, is dedicated to the late Linda McCartney, wife of the musician Paul McCartney. She was Clarke's longtime friend and a distinguished photographer with whom he worked. The repeating fleur-de-lis motif is based on the lily, a flower that for centuries has served as a symbol of royalty. The abstract fields of color are inspired by the sky and water. Clarke chose this theme to reflect Linda McCartney's love of lilies and his own interest in the colors and symbolism of British heraldry. *The Glass Wall* is displayed in the Museum's admissions lobby.

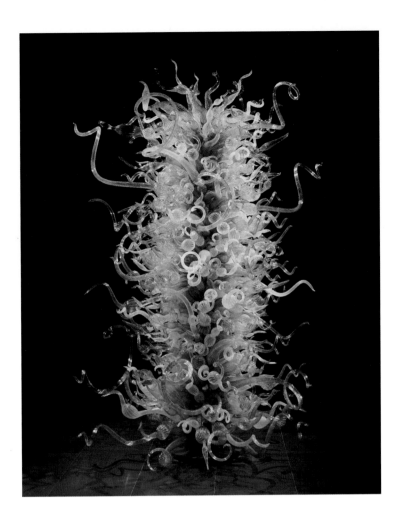

Fern Green Tower

U.S., Seattle, Washington, Dale Chihuly, 2000. H. 335.3 cm (2000.4.6). Gift of the artist.

The prominence of Dale Chihuly (b. 1941) in the field of studio glass is unmatched. Since the 1960s, he has emphasized the sculptural qualities of blown glass, using the vessel as a vehicle for the exploration of color and form. His work is characterized by its gravity-influenced organic shapes, its striking palette of colors, and its strong sculptural expression. *Fern Green Tower* was designed for The Corning Museum of Glass, and it is installed in the admissions lobby. This 1,400-pound sculpture, made of 500 individually blown glass elements attached to a steel structure, is an energetic, seemingly animate mass of color and light. It is one of a series of large-scale towers and chandeliers that Chihuly has produced in a constellation of colors. Exuberant in spirit and ambitious in scope, these impressive glass sculptures are housed in museums, concert halls, corporate offices, public spaces, and private residences around the world.

Untitled (White)

U.S., Seattle, Washington, Josiah McElheny, 2000. L. 218.6 cm (2000.4.9). 2000 Rakow Commission.

The glass installations of Josiah McElheny (b. 1966) are thoughtful compositions on the history of art and glassblowing. This example pays tribute to Modernism and the history of 20th-century glass design. The subject is particularly appropriate for the millennium year, a time of assessing the achievements of the 20th century. McElheny is an accomplished glassblower with a profound respect for the traditions and history of the craft. His choice of color—a brilliant white —and purposeful lack of title refer to Modernist concepts of purity, spareness, and simplicity. The objects, displayed in a 1950s International Style cabinet, honor internationally recognized designers who have influenced McElheny. The glass, from left to right, reproduces designs by Tapio Wirkkala (Finnish), Fulvio Bianconi (Italian), Gunnel Nyman (Finnish), Vittorio Zecchin (Italian, two objects), Oswald Haerdtl (Austrian), Josef Hoffmann (Austrian), Paolo Venini (Italian), Vicke Lindstrand (Swedish), Nils Landberg (Swedish, two objects), Tyra Lundgren (Swedish), Gio Ponti (Italian), and Venini.

Study Gallery

The Study Gallery is an open storage area that is filled with a wide range of objects from all periods. It is named after a donor who gave the Museum an outstanding collection of drinking vessels. Some of these glasses are housed in the main galleries, and others can be seen in the Study Gallery.

Most museums have more objects than space in which those objects can be adequately displayed for visitors. A study gallery is usually intended to be an open storage area. Here, the museum houses most of the objects for which there is no room in the principal galleries.

At The Corning Museum of Glass, the Study Gallery is designed so that a student or collector can study many examples of the type of glass in which he or she is interested. The objects are arranged by subject area—ancient, American, European, Asian, and modern—and by place of origin. Visitors who want to study whiskey flasks, lamps, or cup plates, for example, will be able to see all of these objects in a variety of colors and styles.

The Study Gallery is named after Museum benefactors Jerome and Lucille Strauss. By gift and by bequest, Mr. Strauss provided us with an unparalleled collection of 2,400 drinking glasses dating from ancient to modern times. His wife left us sufficient money to build the gallery. The Strauss Collection is displayed in several locations. The most important pieces are in the primary galleries, and other objects are found in the Study Gallery.

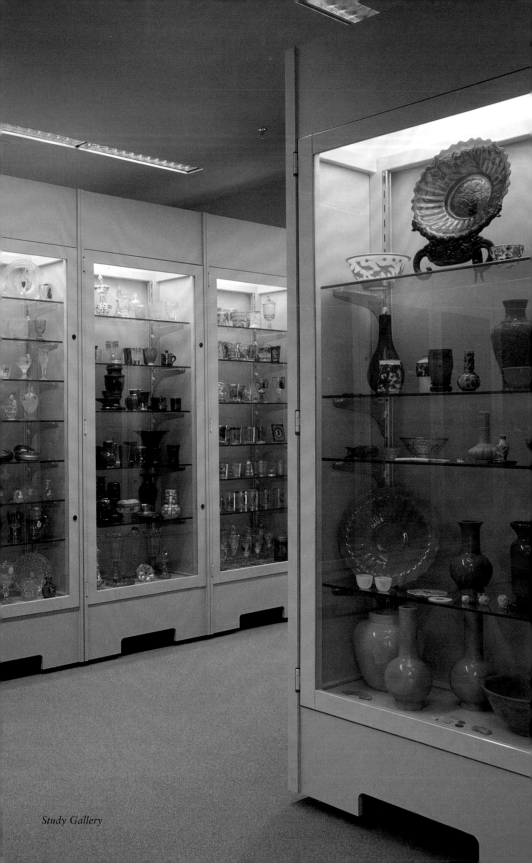

Study Gallery

Carder Gallery

Frederick Carder's distinguished career in glassmaking extended from 1880 to the 1950s. The Carder Gallery displays his early pieces made at the English firm of Stevens & Williams, many of the objects he designed when he managed Steuben Glass Works between 1903 and 1933, and some works he created in his later years.

Frederick Carder (1863–1963), a gifted English designer, managed Steuben Glass Works from its founding in 1903 until 1932. At the age of 14, Carder left school and joined his family's pottery business in Brierley Hill, England. He studied chemistry and technology in night school. In 1879, he became fascinated with glassmaking after visiting the studio of John Northwood, where he saw Northwood's cameo glass replica of the Portland Vase, the most famous piece of ancient Roman cameo glass. One year later, on Northwood's recommendation, Carder went to work as a designer at Stevens & Williams, a large English glassmaking company. There he experimented with glass colors, and he eventually rose to the position of chief designer.

Carder moved to Corning in 1903 at the invitation of Thomas G. Hawkes, owner of Steuben. For the next 30 years, Carder had a free hand in designing that firm's products and developing new colors and techniques. In 1932, when Steuben's new president decided to concentrate on colorless glass, Carder left Steuben to become design director of Corning Glass Works. There he oversaw such large-scale projects as the making of cast panels for Rockefeller Center in New York City. As an octogenarian, he created smaller cast glass sculptures and other one-of-a-kind pieces. Carder's glassmaking career ended in 1959, when, at the age of 96, he finally closed his studio and "retired." During the 82 years in which he worked with glass, he produced many works that are dazzling in their virtuosity. Together, they include hundreds of colors and techniques.

Robert F. Rockwell, a Corning businessman, was Carder's golfing partner and friend in the 1940s. In the following decade, he began to assemble a remarkable collection of Steuben glass. This collection, which was later given to the Rockwell Museum, is now on loan to The Corning Museum of Glass. Most of it is shown in the Carder Gallery, which also houses much of the Carder glass owned by the Corning Museum. Many of the Corning Museum's pieces were gifts from Frederick Carder or from his daughter. There is also a large group of colored Steuben objects, dating from the 1920s and 1930s, that came to the Museum as the gift of Corning Glass Works.

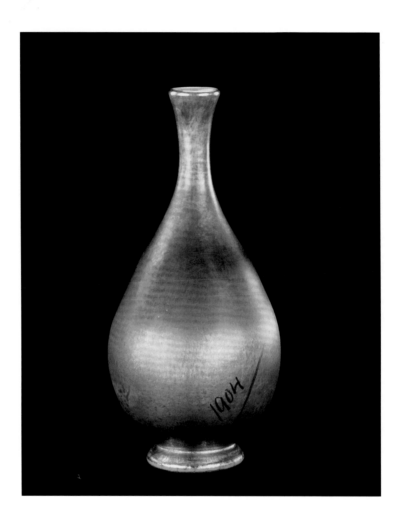

Gold Aurene vase

U.S., Corning, New York, Steuben Glass Works, dated 1904. H. 14.1 cm (Rockwell Museum, R77.268).

Gold Aurene was the first new color developed by Carder at Steuben. In the 1890s, he had become fascinated by the golden and rainbow-colored iridescence on ancient Roman glass, which had been caused by weathering while the glass was buried in soil. After years of experimentation, Carder achieved a velvety soft iridescence in 1904 by spraying the hot glass with stannous chloride. He coined the name "Aurene" by combining the first three letters of the Latin word for "gold" (*aurum*) and the last three letters of the Middle English form of "sheen" (*schene*). In 1905, he developed a blue version of Aurene. Very few Aurene glasses were decorated because Carder thought these pieces were so beautiful that they required no further ornamentation. Iridescent glass did not originate with Carder. He admitted that Bohemian glassmakers had been producing it for several decades before he started to work with it.

Rouge Flambé bowl

U.S., Corning, New York, Steuben Division, Corning Glass Works, about 1924–1926. D. 16.0 cm (Rockwell Museum, R82.4.45). Bequest of Frank and Mary Elizabeth Reifschlager.

This deep opaque red glass, known as Rouge Flambé, was the most difficult shade that Carder tried to make. He was never satisfied with the result. The red varied from batch to batch, and that explains why the few surviving pieces do not look alike. Rouge Flambé, which was produced commercially only in the early 1920s, was inspired by Chinese porcelain glazes. This glass is sometimes erroneously called Red Aurene. It is not iridescent, and its bright surface was not created by spraying the glass with oxides. Instead, it is colored with cadmium sulfide and cadmium selenide. Rouge Flambé pieces are very rarely marked, but they can sometimes be identified by the shape and finish.

Intarsia vase

U.S., Corning, New
York, Steuben
Division, Corning
Glass Works,
1920s. H. 17.4 cm
(69.4.221). Bequest
of Gladys C. Welles.

Carder considered Intarsia to be his greatest achievement. In 1916, Swedish glassmakers had developed the Graal technique, in which colored reliefs were cased in crystal and the surface was then smoothed. Carder experimented with this technique in 1916 or 1917, and he started commercial production of Intarsia in the 1920s. He made bowls, goblets, and vases with a floral or foliate design in a thin layer of colored glass sandwiched between two thin layers of colorless glass. The vase shown here was made in an unusual combination of colors. The amethyst design is enclosed between two layers of French blue. Most of Carder's Intarsia glass bears the engraved facsimile signature "Fred'k Carder." This glass was not produced in large numbers, and very few examples are known today.

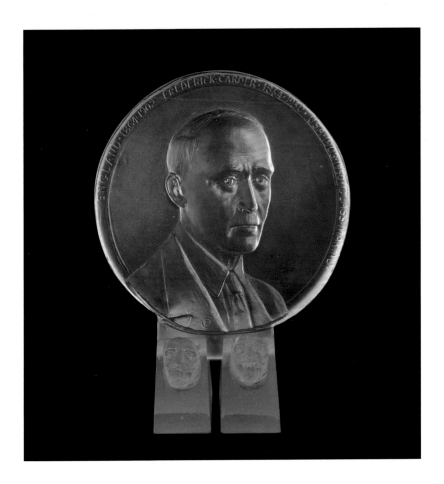

Cast glass sculpture, bust of Frederick Carder

U.S., Corning, New York, Frederick Carder, 1951. D. 22.6 cm (59.4.362). Gift of Corning Glass Works.

For three decades, perfecting the *cire perdue* (lost wax) process of glass casting was one of Carder's principal activities. This complex technique begins with the production of an object in wax or plaster. The artist then creates a mold around the object and makes a wax copy. When the mold is complete, it is heated and the melted wax is removed. The mold is then filled with lumps of glass and heated to melt the glass. The wax model is melted, and the mold is broken to remove the glass. This is Carder's self-portrait. It was made when he was 88 years old. In the 1950s, Carder used the lost wax method to create his extremely complicated Diatreta pieces, which were based on fourth-century Roman cage cups.

For Further Reading

The principal sources for information about major additions to the Corning Museum of Glass collection are the *Annual Report* and the "Recent Important Acquisitions" section of the *Journal of Glass Studies*. In the *Annual Report*, each of the Museum's curators briefly discusses the background and significance of the year's major purchases and gifts. The *Report* is distributed to Members of the Museum.

Two general surveys of glass objects in the Museum's collection are Robert J. Charleston's *Masterpieces of Glass: A World History from The Corning Museum of Glass* (Abrams, 1990) and Susanne K. Frantz's *Contemporary Glass: A World Survey from The Corning Museum of Glass* (Abrams, 1989).

For a scholarly treatment of the collection, including complete descriptions and discussions of the objects and their parallels, readers should consult the Museum Collections Catalog Series. Three volumes are available: *Roman Glass* (v. 1, 1997, and v. 2, 2001; v. 3 is to be published in 2002) by David Whitehouse and *American and European Pressed Glass* by Jane Shadel Spillman (1981).

Books for general audiences on various aspects of glass history include Chloe Zerwick's *A Short History of Glass* (rev. ed., Abrams, 1990), David Whitehouse's *Glass of the Roman Empire* (1988) and *English Cameo Glass in The Corning Museum of Glass* (1994), and Jutta-Annette Page's *Designs in Miniature: The Story of Mosaic Glass* (1995).

Readers who would like more information on American glass can turn to *Masterpieces of American Glass* by Jane Shadel Spillman and Susanne K. Frantz (Crown, 1990). Corning's role as a leading producer of cut and engraved glass in the 19th and 20th centuries is traced in Ms. Spillman's *The American Cut Glass Industry: T. G. Hawkes and His Competitors* (Antique Collectors' Club, 1996) and *The Complete Cut & Engraved Glass of Corning* by Estelle F. Sinclaire and Ms. Spillman (rev. ed., Syracuse University Press, 1997).

The Studio of The Corning Museum of Glass is producing a series of videotapes that will acquaint viewers with some of the leading contemporary glass artists and their techniques. The four titles published to date profile the Muranese master glassblower Lino Tagliapietra, The Studio's William Gudenrath and Venetian glassmaking techniques, the Czech engraver Jiří Harcuba, and the Japanese *pâte de verre* artists Shin-ichi and Kimiake Higuchi.

Words and phrases that describe glassmakers' materials, techniques, tools, and products are defined in David Whitehouse's *Glass: A Pocket Dictionary of Terms Commonly Used to Describe Glass and Glassmaking* (1993).

(Unless otherwise noted, all of these titles are published by The Corning Museum of Glass. The books and videotapes listed here are available for purchase from the Museum's Buying Office. For information about additional resources on glass and glassmaking, readers are invited to send inquiries to the Museum's Rakow Research Library.)